THE GREAT BOOK OF

French Impressionism

DIANE KELDER

Professor of Art History, College of Staten Island,
City University of New York

A TINY FOLIO™

Publishers
ondon

Front cover: Claude Monet, *Rue Saint-Denis* (major portion), 1878.
 Musée des Beaux-Arts, Rouen.
Back cover: Vincent van Gogh, *Van Gogh's Chair and Pipe*, 1888–89.
 The Tate Gallery, London.
Spine: Pierre-Auguste Renoir, *Dance in the Country*, 1883. Musée d'Orsay, Paris.
Frontispiece: Vincent van Gogh, *Stairway at Auvers* (major portion), 1890.
 Saint Louis Art Museum.

First hardcover Tiny Folio™ edition

15 14 13 12 11 10 9 8 7 6 5

Library of Congress Catalog Card Number 84-48463

ISBN 978-0-7892-0405-9

For bulk and premium sales and for text adoption procedures, write to Customer
Service Manager, Abbeville Press, 655 Third Avenue, New York, NY 10017,
or call 1-800-ARTBOOK.

Visit Abbeville Press online at www.abbeville.com.

THE GREAT BOOK OF French Impressionism

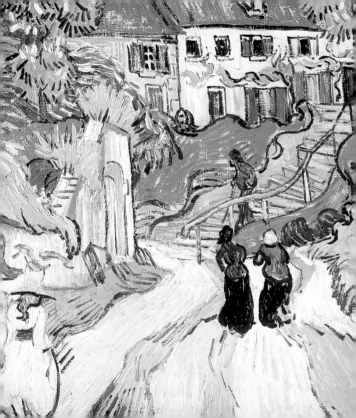

Contents

Introduction

Toward a Vision of Modern Life

Edouard Manet: Reluctant Revolutionary

The New Painting

Claude Monet: Impressionist par Excellence

Pierre-Auguste Renoir: The Exuberant Impressionist

Edgar Degas and Henri de Toulouse-Lautrec: The Studied Moment

The Impressionists in 1886

Paul Cézanne and the Legacy of Impressionism

List of Plates

INTRODUCTION

Nineteen seventy-four marked the centennial celebration of a remarkable exhibition that announced the determined efforts of a group of painters to show their work, free of the traditional constraints imposed by a hierarchic and self-perpetuating art establishment. More than any other movement in the history of art, Impressionism, and the painters associated with it, contained the essential ingredients of popular mythology. Initially misunderstood by the public, reviled by critics, and ignored by all but a few devoted collectors, this small band of dedicated artists nevertheless struggled on to achieve both tangible financial success and, in the judgment of posterity, critical vindication. Within an amazingly brief period, they managed to wrest painting from its theoretical and technical moorings in the past.

The Impressionists firmly rejected the notion that an artistic subject had to have intrinsic literary value, that it had to be noble or instructive in order to be worthy of representation. Their commitment to the present made them uniquely conscious of and responsive to the ever-shifting physical reality of the moment, and stimulated them to develop new techniques for capturing its fleeting essence. Instead of painting what they knew, as artists had done before them, they limited themselves to painting what they saw. Like Elstir, the quintessential Impressionist invented by Marcel Proust in *A la recherche du temps perdu,* they made a strenuous effort ''to rid [themselves] in the presence of reality, of . . . notions of intelligence.'' Their pursuit of reality dictated certain innovations: As they came to realize that only direct contact with the subject in open air would produce the effects they sought, they abandoned their studios, adopted smaller-scale canvases that could be carried about easily, and, most important, altered their palette and brushstroke to simulate the rapidly changing atmosphere that they wished to capture.

One hundred years after their inaugural exhibition, such canvases as Monet's *Impression, Sunrise* (c. 1872) or *Boulevard des capucines* (1873)—which were singled out as particularly egregious examples of ineptness or incompleteness—no longer shock the public. When a rare Impressionist painting now comes up for auction, museums and maecenases compete furiously to pay an astronomical price for it. While popular interest in Impressionism seems limitless, the critical and historical interest in the movement seems to have peaked in the early 1960s, when its apparent relevance to Abstract Expressionism and color field painting instigated a reassessment of the movement and of the entire historical context from which it emerged. A more balanced perspective of historical Modernism, as well as a clearer picture of the contributions of major and minor artists, is currently emerging from studies of that

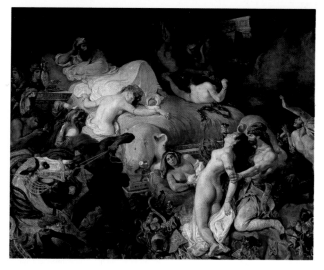

1. Eugène Delacroix *Death of Sardanapalus,* 1827–28
Louvre Museum, Paris

intersection of tradition and contemporaneity, Japonisme and technology, whose impact was first reflected in the work of the Impressionists.

The Impressionists were among the first artists to be motivated by a sense of common purpose. While the individual painters were separated by background and temperament, they were united in their desire to bring their work before the public. Though many of them were born outside of Paris, it was only in the capital that they felt they could make their mark, for the city was not only the center of an empire—that of the ambitious Napoleon III—but also the center of the art world. Napoleon's

policies of political expansionism were matched by his vision of Paris as the cultural capital of a French-dominated Europe. One of his major priorities, the physical transformation of Paris from a city of narrow, arbitrarily arranged streets and houses to the very model of a modern metropolis, was accomplished through the genius of the civil engineer Baron Georges Haussmann. His broad, light-filled boulevards literally opened up new vistas and created new subjects for the burgeoning group of young painters.

For most of the Impressionists, the commitment to one's own time presupposed a rejection of the past and all the respectful attitudes associated with tradition and

2. James McNeill Whistler *Caprice in Purple and Gold No. 2: The Golden Screen,* 1864
Freer Gallery of Art, Washington, D.C.

experience, even though there was nothing particularly new in the juxtaposition of past and present, or ancient and modern. Since the seventeenth century, the members of the prestigious *Académie royale de peinture, sculpture, etc.* had debated the merits of Rubens versus Poussin, color versus drawing. The artists of the Académie were regarded as the only valid practitioners of high art; predictably, their views were not conducive to the development of independent artistic creativity. Early in the nineteenth century, the rigid academic hierarchy was relaxed somewhat to allow students of landscape painting the privilege of competing for a prestigious fellowship to perfect their craft in Rome, but landscape painting continued to be considered a minor pursuit next to historical or mythological themes.

The ascendance of Ingres and of the cultivated and eclectic styles of his academic followers reverberated through the halls of the Ecole des Beaux-Arts and the walls of the official Salons, where painters' reputations were made. There, numerous examples of correct drawing and impeccable finish proclaimed the superiority of painting that had *ideas* as its focus. The art of more "liberal" masters such as Eugène Delacroix, the greatest French exponent of color before the Impressionists, was not exempt from this love affair with history and literature. Although Delacroix was capable of responding to contemporary issues, he limited those issues to appropriately significant and heroic themes inspired by national or international crises; and they were enunciated, for the most part, in the visual language of the past.

It is understandable that Napoleon III, whose political appeal was linked to a nostalgia for the glory of his uncle's empire, should have endorsed a retrospective and eclectic art, and that he should appoint a man of aristocratic tastes, Count Nieuwerkerke, to oversee the academic factories where art products were turned out. The older patrons of this art, if not some branch of the government itself, were the middle and upper middle class. The former, growing steadily in number and influence since the reign of Louis-Philippe (1830–48), took their cue from the Salons and filled their already stuffed townhouses and country châteaux with *grandes machines*—elaborate pastiches of classical, medieval, or Renaissance themes or the acceptable contemporary exoticism, usually depicted in the guise of some Middle Eastern motif.

The exhibition of the *Société anonyme des artistes, peintres, sculpteurs, graveurs, etc.* (the original name chosen by the artists who exhibited in 1874) was the culmination of a revolt against the art establishment that had been initiated almost twenty years before by Gustave Courbet. His decision to mount a one-man show independent of the official exhibition was to inspire a similar tactic by Edouard

Manet twelve years later. Courbet championed a "concrete" art, dealing exclusively with the experience of its own time—an accountable art of physical facts, with common men rather than heroes as its protagonists. Courbet's approach coincided with and was probably conditioned by the rise of scientific materialism and literary Naturalism. It was as much a rebuke to the idealizing aesthetics of official art as the vulgar and mechanical art of photography, whose terrifying capacity to reflect the truth had prompted a noted painter of the day to proclaim the demise of painting two decades earlier. Indeed, the role played by photography in the evolution of modern vision, particularly that of the Impressionists, was critical to the liberation of painting from traditional formulas and spatial stereotypes.

Just as Impressionism cannot be fully understood without considering the contributions of prominent Realists such as Courbet, the significant achievements of a loosely knit group of landscape painters working in or near Barbizon, a small town on the edge of the forest of Fontainebleau, must be acknowledged. Inspired by the seventeenth-century Dutch masters and by the vivid canvases of their near contemporary, the English landscapist John Constable, they sought a close personal identification with nature. In its constant shifting of atmosphere and changing of seasons, they found a perfect mirror for their own moods. Many of the innovations in technique usually associated with the Impressionists, including the practice of working out of doors, were actually anticipated by such members of the group as Daubigny. Outstanding among them—though by no means the most typical exponent of that unadorned and rugged atmospheric quality common to the group as a whole—was Camille Corot, whose example was to fire the imagination of Camille Pissarro and of his younger colleagues Claude Monet, Pierre-Auguste Renoir, and Frédéric Bazille.

The lure of Barbizon and its renowned forest proved as irresistible to this small band of ex-Beaux-Arts students as it had to Corot's generation. In their novel *Manette Salomon,* the Goncourt brothers described the forest of Fontainebleau as "full of impecunious bearded young painters carrying easels." But Barbizon was only one of many new locales that attracted the future Impressionists. The wide beaches of Normandy first painted by Eugène Boudin also provided new sensations of light and opened their eyes to the fascinating properties of water and sky.

While innovations in landscape painting provoked either disapproval or indifference in official circles, the dissatisfaction with the selection process for the Salons, which had largely been a personal affair, achieved the dimensions of a genuine popular protest when more than half of the works submitted to the Salon of 1863 were rejected. The uproar was so great that Napoleon III, ignoring the objections of the

3. Maurice Denis *April,* 1892
Rijksmuseum Kröller-Müller, Otterlo

Académie, authorized the creation of a separate exhibition in the same building that housed the official Salon. From the first day, the Salon des Refusés overshadowed the prestigious exhibit next door. A mixture of old and new, bad and good, this unprecedented assemblage of paintings alternately amused and offended the curious visitors who streamed in. While some of the exhibitors—Pissarro, Henri Fantin-Latour, Paul Cézanne, and the American James McNeill Whistler—would later achieve prominence within the history of Impressionism or, more generally, of Modernism, it was a work by Edouard Manet, *Déjeuner sur l'herbe* (1863), that came to symbolize the audacious presumption of the new breed of painters. Henceforth, *refusé* was synonymous with revolutionary; and in the public's mind, Manet was the arch-revolutionary.

While Manet's unorthodox juxtaposition of the traditional and the contemporary provoked moral outrage, his technical innovations stirred up a critical hornet's nest

that buzzed for more than a decade. Younger artists such as Monet and Bazille immediately took up the challenge of placing life-size figures in a landscape, imbuing their canvases with a straightforward modernity in the process. The persistence of the Picnic and Bather themes, which were combined in Manet's epochal work, constitutes one of the most significant chapters in the history of modern painting, culminating in Cézanne's great series, wherein the essential clash of subject and technique, of tradition and innovation first acknowledged in Manet's work was resolved in works that are at once classical and proto-abstract.

Although Manet's work and his decision to organize a one-man show at the

4. Paul Gauguin *The Day of the God (Mahana No Atua)*, 1894
Art Institute of Chicago; Helen Birch Bartlett Memorial Collection

Paris World's Fair in 1867 met with the approval of the artists who would later form the nucleus of the Impressionists, he can be considered at best only the godfather of the movement rather than a bona fide member. At the time of Manet's exhibition, Monet, Renoir, Pissarro, and Sisley were already seriously pursuing landscape. The sense of the fugitive and the momentary that they sought was purely physical, not social or psychological in implication as in the work of Manet. No longer satisfied with motifs provided by the parks or gardens of Paris, the group of young artists moved into rural suburbs or more distant villages. There, in their images of the Seine and the adjacent landscape, they gradually eliminated all human references in order to concentrate on the seemingly inexhaustible variety of atmospheric effects produced by the volatile climate.

While the painting styles of Monet and Renoir, especially, seemed to converge in those years preceding the first Impressionist exhibition, the group was heterogeneous enough to accommodate independents like Edgar Degas, whose interest in interior subjects and portraiture set him apart from the mainstream. For Degas, the tyranny of the moment—what Monet called the search for instantaneity—was a serious impediment to the realization of pictorial structure. His initial reservations about landscape painting and the technical and compositional changes it had wrought were later to be shared by Renoir and even by Pissarro, generally considered the most loyal Impressionist of them all. Never comfortable with the label ''Impressionist,'' which had been imposed on the group by a hostile critic, Degas nonetheless accommodated the group in its larger mission of exhibiting work that might otherwise have gone unseen. Renoir, on the other hand, broke completely with his former colleagues when he began to realize that their preoccupation with those spontaneous and random elements that emerged from a direct but finite contact with his subject were antithetical to his true interests, the unification of firm design and sensuous color.

Impressionism as a group phenomenon was already beset by dissension when it reached its fifth birthday; and by its tenth, the artists who had once been its heart and soul were dispersed in both location and philosophy. Of the eight exhibitions held between 1874 and 1886, only one artist— Camille Pissarro—took part in all; Degas showed in seven; Monet participated in five; Renoir, four; and Cézanne, just two. When the final group exhibition was held, it was not the few remaining older Impressionists who claimed the attention of the critics, but younger artists such as Georges Seurat. His major canvas, *A Sunday Afternoon on the Island of La Grande Jatte* (1884–86), seemed to be in the tradition of plein-air painting, but actually proclaimed a highly programmatic and theoretical reform of the direct, intuitive, and

largely individualized approach to painting that had evolved in the previous two decades. Ironically, Seurat's contribution of a genuine system to organize the pure color of the Impressionists into a coherent pictorial structure actually resulted in a schematization of art in symbolic and decorative terms, which was as antithetical to the Impressionists' methods and objectives as the art they had initially defied.

The crisis of Impressionism, exemplified in the emergence of a vigorous reforming "Neoimpressionism," was not limited to dissatisfaction with its technique, but also with its unresponsiveness to the mind and soul. The manifesto of Symbolism published in 1886 gave concrete expression to a widespread defection from literary and artistic Naturalism, which some of the Impressionists had in one way or another already acknowledged. Van Gogh, who had never exhibited with the Impressionists, and Gauguin, who had joined them on five occasions, both moved beyond the use of color for the transcription of physical effects to a realization of its emotional, expressive, and ultimately decorative potential. With them and their heirs, the Nabis and the Fauves, color and line were to achieve a final independence from physical stimuli, anticipating the various forms of color abstraction that have been part of the art of this century.

The obsession with time that began to manifest itself in the early years of Impressionism adumbrated the unique development of Monet, who symbolized for many the Impressionist par excellence. From a relatively straightforward concern with capturing the appearance of a sun-filled street or a rainy beach, he moved to a more dramatic awareness of the vitality of time, returning again and again to a subject in order to realize more completely its changing identity. Later, this determination to capture the instant caused him to work on several paintings at a time, switching from one to the other, stopping, resuming in a maddened effort to seize the very essence of time.

Not until the last decade of the century, some five years after the last Impressionist exhibition, did Monet discover the technique that would carry him farther than any of his colleagues in his study of time. The "series" paintings of haystacks, poplars, and cathedral facades made him conscious as never before of the continuum of time and of its distinct expressions. As he worked on the many versions of these themes over hours, days, and months, that objectivity that had once characterized his approach to landscape was transformed into a subjective, even autobiographical record of his reactions to the motif. In the last twenty-five years of his life, with nearly all of his old friends long dead, Monet's world was defined by the physical limitation of the carefully designed gardens of his home at Giverny. Prolonged

contemplation of these gardens, especially the lily pond, made him aware of the continuity of physical life and time; the water garden came to represent a synthesis of being and becoming. The timelessness and infinitude that emanate from his *Nymphéas* or Water Lilies transport us beyond the world of simple events to a magical and remote environment, whose full identity only begins to emerge when one sees it unfold through the entire body of eight canvases he executed for two specially constructed oval rooms in the Orangerie.

The year Monet began his first Water Lilies, Paul Cézanne embarked on a canvas that was to occupy him, on and off, for six of his last seven years. *Large Bathers* (1899–1905) was the most complex version of a theme he had painted since his years as a sometime member of the Impressionist group. Even then, his frustrations with the limits of Impressionist technique had led him to seek a new way of uniting their lighter, pure colors and direct observation of the world with that innate sense of structure that he perceived in nature. Through his brushwork, land, water, and sky were given a palpable and homogeneous identity as the painter realized his dream of making Impressionism "solid and durable like the art of the museums." As with Manet, tradition was to play a paradoxically important role in Cézanne's turning away from Impressionism to a more transcendent and ultimately modern vision of painting. His late Bathers, landscapes, and still-life paintings invite comparison with that sense of architectural form glimpsed in the historical and mythological subjects of Poussin and the still lifes of Chardin.

Yet it is precisely in confrontation with the past that the impact of Cézanne's new approach can be appreciated. More than any other member of the Impressionist group, Cézanne identified the character of early modern painting. Rigorously analytic, lacking totally the lightness and charm associated with the earlier history of the movement, his grave works would have looked odd indeed at either the Salon or the Impressionist shows. But when they were exhibited at a great memorial show in 1907, their irregular, ponderous forms and ambiguous space spoke to Georges Braque and Pablo Picasso, the engineers of yet another aesthetic revolution, Cubism, which was to alter the course of Western art.

TOWARD A VISION OF MODERN LIFE

In the Great Exposition Universelle of 1855, Dominique Ingres, Eugène Delacroix, and artists closely allied with official Salons and academic ateliers garnered most of the show's honors with works on historical, mythological, and religious themes. However, that there were cracks in this official sanctification of history painting was revealed by comments in the popular press. Charles Baudelaire, the most astute critic of the day, sang the praises of Delacroix *not* for his subject matter or grandness of portrayal but for his brilliant and fluid colorism.

Landscape painting had suffered the stigma of inferiority to history painting until well into the nineteenth century, but in 1816 a Prix de Rome established for landscape by the Ecole des Beaux-Arts signaled official recognition of the genre. J.B.C. Corot, his vision honed by his days observing and painting in the Italian light, returned to France in the late 1820s, and, in a sense, was deified by a group of painter "realists" known as the Barbizon school. These painters, in part inspired by English landscapists such as Constable and Turner, had as a common interest the exploration of atmosphere, locale, and contemporary life. Daubigny, Daumier, Courbet, Millet, and others documented what they "saw," but in ways heretofore unacceptably unadorned for the Salons.

From these beginnings, a vision of modern life in art developed in France with depictions of the hitherto unheralded activities of lower-class Paris, poor farmers at work in the fields, the daily concerns of the bourgeoisie, Sunday outings in the country, and the atmospheric effects of nature. Added to these were the effects of man upon the natural world—his technological inventions that altered the appearance of the world as well as his activities within that world. Even current events, often presented in harsh realism, could become the subject of paintings (minus the glorification or prettiness required in another age).

And so the Impressionists found their freedom in the world around them and their mentors among those who had already broken new ground. What the Impressionists left us was a legacy of unparalleled variety that has become the way we have pictured French society and life during the second half of the nineteenth century.

1. Jean-Auguste-Dominique Ingres *Odalisque and Slave*, 1842
Walters Art Gallery, Baltimore

2. Eugène Delacroix *Liberty Leading the People*, 1830
Louvre Museum, Paris

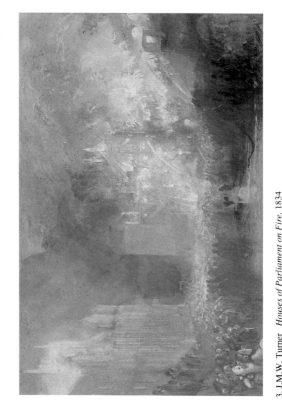

3. J.M.W. Turner *Houses of Parliament on Fire*, 1834
British Museum, London; Reproduced by courtesy of the Trustees of the British Museum

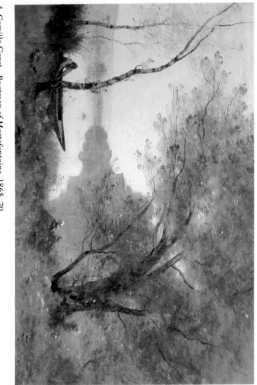

4. Camille Corot *Boatman of Mortefontaine*, 1865–70
The Frick Collection, New York

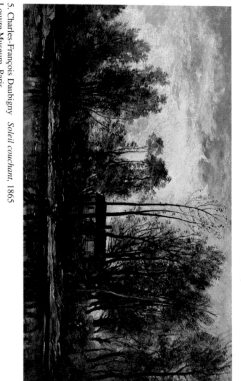

5. Charles-François Daubigny *Soleil couchant*, 1865
Louvre Museum, Paris

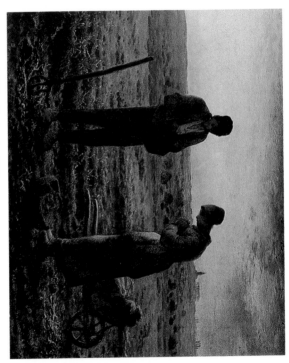

6. Jean-François Millet *The Angelus*, 1867
Louvre Museum, Paris

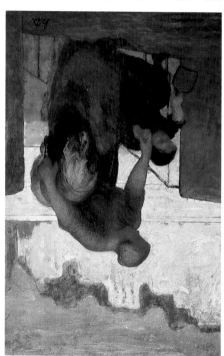

7. Honoré Daumier *The Laundress*, c. 1861–63
Louvre Museum, Paris

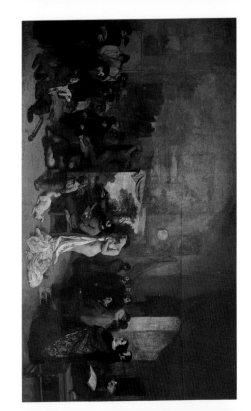

8. Gustave Courbet *The Painter's Studio*, 1855
Musée D'Orsay, Paris

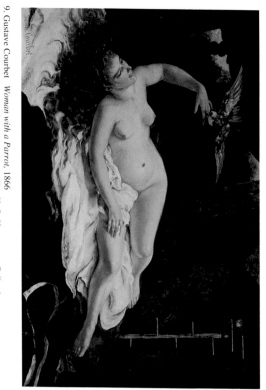

9. Gustave Courbet *Woman with a Parrot,* 1866
The Metropolitan Museum of Art, New York: The H. O. Havemeyer Collection

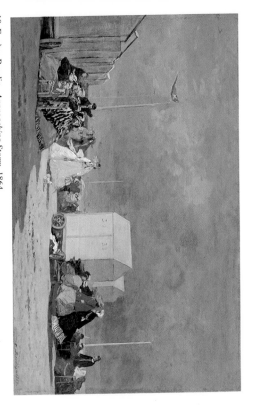

10. Eugène Boudin. *Approaching Storm*. 1864
Art Institute of Chicago; Gift of Annie Swan Coburn to the
Mr. and Mrs. Lewis L. Coburn Memorial Collection

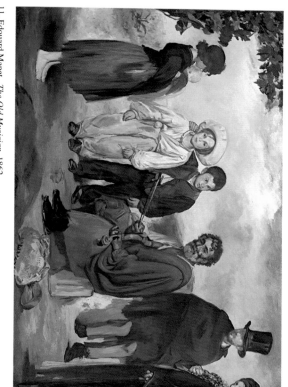

11. Edouard Manet *The Old Musician*, 1862
National Gallery of Art, Washington, D.C.: Chester Dale Collection

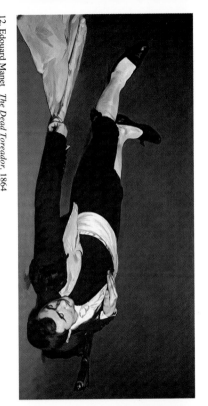

12. Edouard Manet *The Dead Toreador*, 1864
National Gallery of Art, Washington, D.C.; Widener Collection

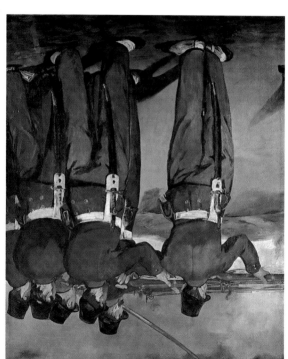

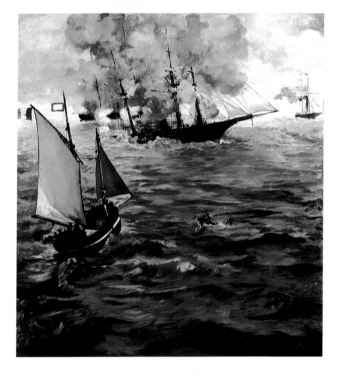

14. Edouard Manet *Battle of the* Kearsarge *and the* Alabama, 1864
Philadelphia Museum of Art; The John G. Johnson Collection

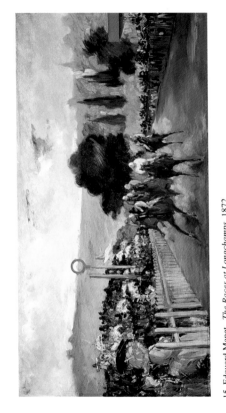

15. Edouard Manet *The Races at Longchamps*, 1872
Art Institute of Chicago; Potter Palmer Collection

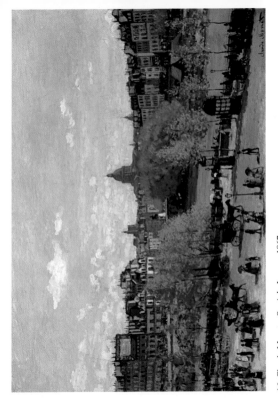

16. Claude Monet *Quai du Louvre*, 1867
Haags Gemeentemuseum, The Hague

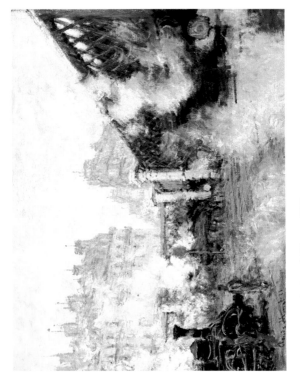

17. Claude Monet *Le Pont de l'Europe*, 1877
Musée Marmottan, Paris

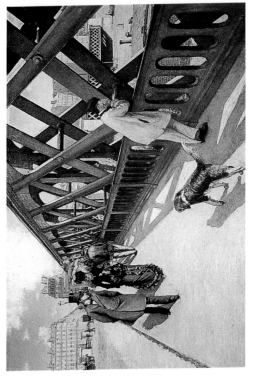

18. Gustave Caillebotte *Le Pont de l'Europe*, 1876
Musée du Petit Palais, Geneva

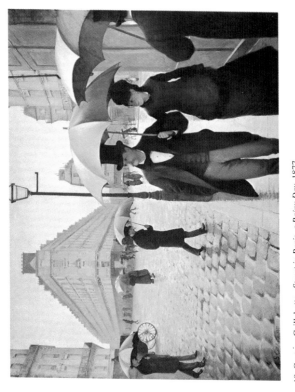

19. Gustave Caillebotte *Street in Paris, a Rainy Day,* 1877
Art Institute of Chicago; Charles H. and Mary F. S. Worcester Collection

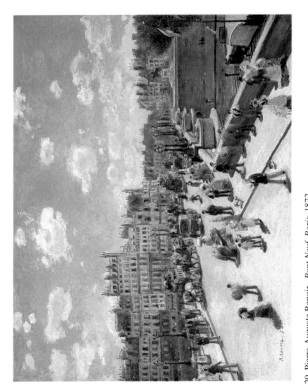

20. Pierre-Auguste Renoir *Pont Neuf, Paris*, 1872
National Gallery of Art, Washington, D.C.; Ailsa Mellon Bruce Collection

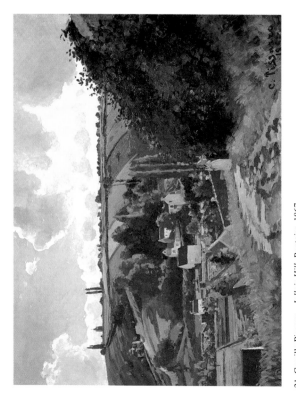

21. Camille Pissarro *Jallais Hill, Pontoise*, 1867
The Metropolitan Museum of Art, New York; Bequest of William Church Osborn

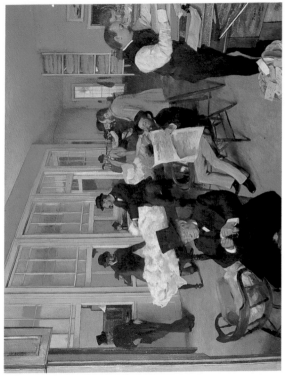

22. Edgar Degas *Portraits in an Office: The Cotton Exchange, New Orleans*, 1873
Musée des Beaux-Arts, Pau, France

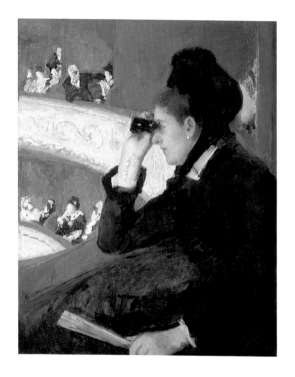

23. Mary Cassatt *Woman in Black at the Opera,* 1880
Museum of Fine Arts, Boston; Charles Henry Hayden Fund

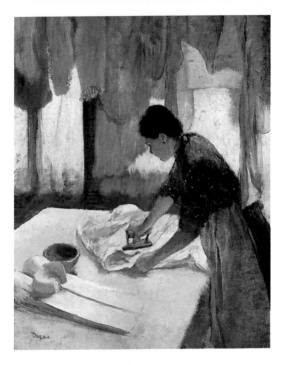

24. Edgar Degas *Woman Ironing,* 1882
National Gallery of Art, Washington, D.C.;
Collection of Mr. and Mrs. Paul Mellon

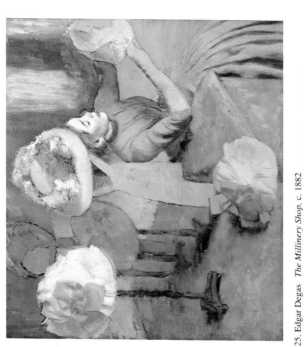

25. Edgar Degas *The Millinery Shop*, c. 1882
Art Institute of Chicago; Mr. and Mrs. Lewis L. Coburn Memorial Collection

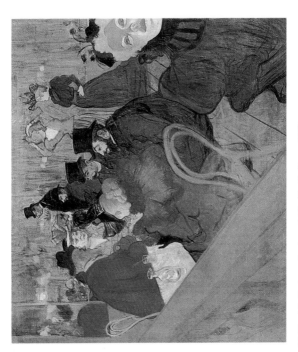

26. Henri de Toulouse-Lautrec *At the Moulin Rouge*, 1892
Art Institute of Chicago; Helen Birch Bartlett Memorial Collection

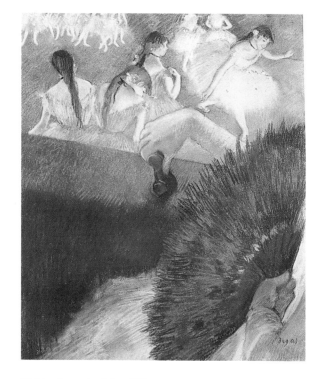

27. Edgar Degas *Au théâtre,* 1880
Durand-Ruel Collection, Paris

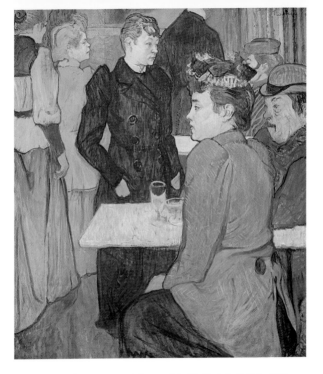

28. Henri de Toulouse-Lautrec *A Corner of the Moulin de la Gallette,* 1892
National Gallery of Art, Washington, D.C.; Chester Dale Collection

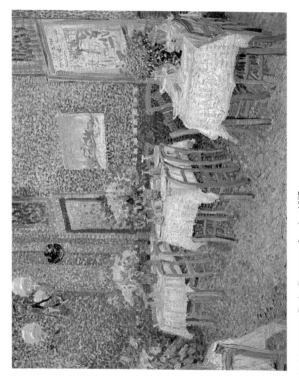

29. Vincent van Gogh *Restaurant Interior*, 1887
Rijksmuseum Kröller-Müller, Otterlo

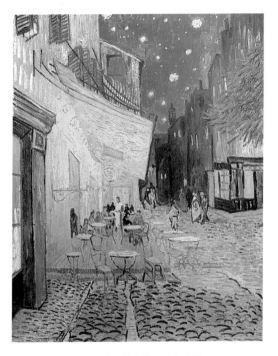

30. Vincent van Gogh *Sidewalk Café at Night,* 1888
Rijksmuseum Kröller-Müller, Otterlo

EDOUARD MANET:

Reluctant Revolutionary

Paradoxically, Manet was an independent who nonetheless believed that he could realize his artistic aspirations only within the framework of the establishment. He persisted in this conviction, although he repeatedly provoked controversy. Ultimately, the recognition he sought in official circles occurred only after his death in 1883; within his own circle his greatness had been recognized some twenty years earlier.

With his independent spirit and a preference for ordinary models in contemporary clothing and scenes, Manet was inevitably led to a confrontation with the traditional historicism of fine art. Although drawn to the work of the old masters (among them Titian, Rembrandt, and Velázquez), he gravitated toward painting contemporary man—from café regulars to ragpickers—insisting upon a new sense of informality and casualness in art.

It was Baudelaire who as early as 1861 designated Manet as "the Painter of Modern Life," after viewing Manet's contributions to the official Salon of that year. In 1863 the works he submitted to that Salon were refused, but he declined to consider himself at the center of the rebellion leading to the Salon des Refusés, even though he had petitioned the minister of state for changes in the official selection process and became the Refusés' most famous participant. But the controversy raised by Manet's work gained him stature among younger painters, so that by the time he independently chose to exhibit his work outside the Salon in 1867, he had received the adulation of a sizable group of artists who hailed him as their leader—among them Monet, Renoir, and Bazille.

While Manet continued throughout his lifetime to proclaim his belief in the effectiveness of the Salon, he found acceptance among those who were to reject it—primarily the Impressionists, who found in his work both a freshness in its contemporary themes and a "modern" rendering in his historical subjects. Thus, as he influenced others so was he affected by those around him. In working with Renoir and Monet briefly at Argenteuil in 1874, he discovered the palette and freshness that were the hallmarks of the Impressionists during their formative years and used them to great advantage in his work. And from there until the end of his life, much of his work (to our contemporary eye) was squarely with the Impressionists.

1. Edouard Manet *Olympia,* 1863
Musée D'Orsay, Paris

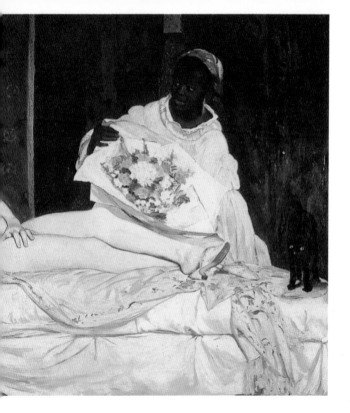

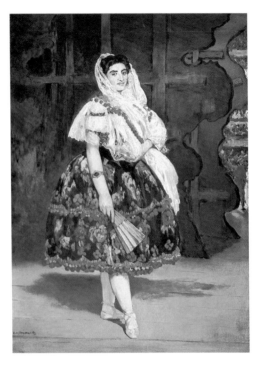

2. Edouard Manet *Lola de Valence,* 1862
Musée D'Orsay, Paris

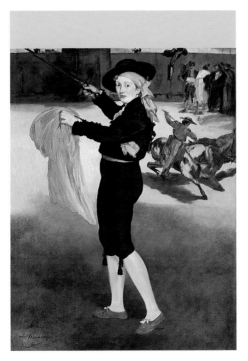

3. Edouard Manet *Mademoiselle Victorine in the Costume of an Espada.* 1862. The Metropolitan Museum of Art, New York; The H. O. Havemeyer Collection

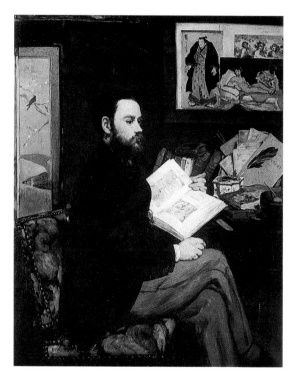

4. Edouard Manet *Portrait of Emile Zola*, 1868
Musée D'Orsay, Paris

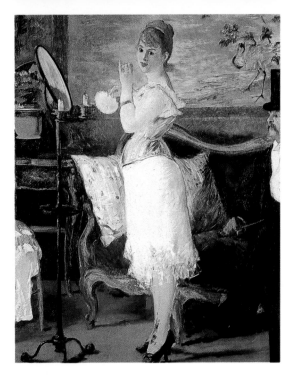

5. Edouard Manet *Nana,* 1877
Kunsthalle, Hamburg

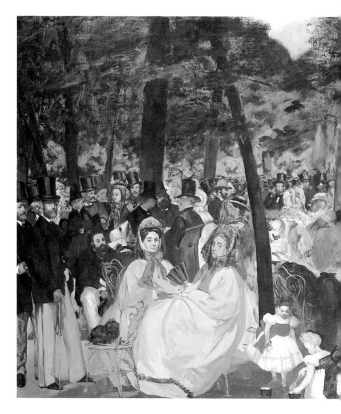

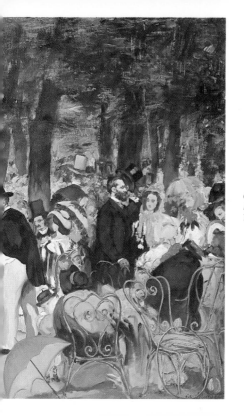

6. Edouard Manet *Music in the Tuileries*, 1862 National Gallery, London

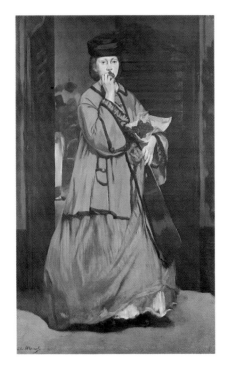

7. Edouard Manet *The Street Singer,* 1862
Museum of Fine Arts, Boston;
Bequest of Sarah Choate Sears

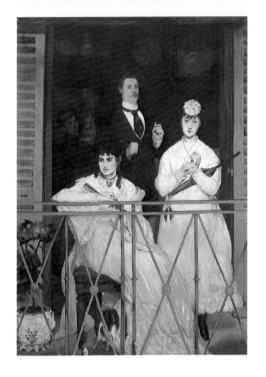

8. Edouard Manet *The Balcony,* 1868–69
Musée D'Orsay, Paris

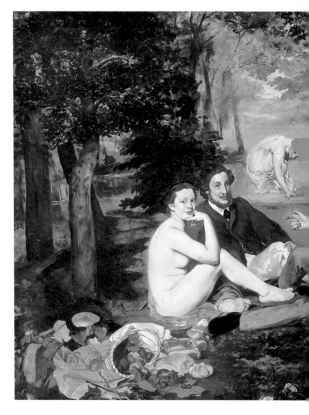

9. Edouard Manet *Déjeuner sur l'herbe
(Luncheon on the Grass),* 1863
Musée D'Orsay, Paris

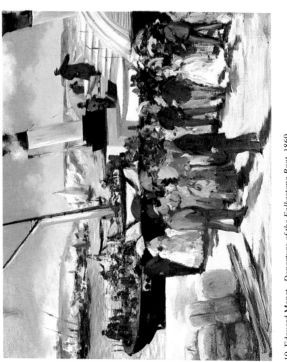

10. Edouard Manet *Departure of the Folkestone Boat*, 1869
Philadelphia Museum of Art; Given by Mr. Carl Zigrosser

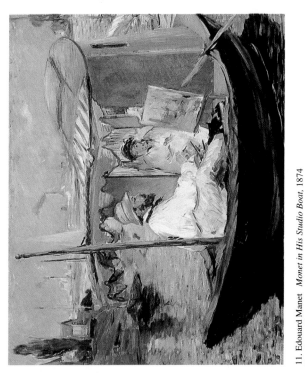

11. Edouard Manet *Monet in His Studio Boat*, 1874
Der Bayer Staatsgemaldesammlungen, Munich

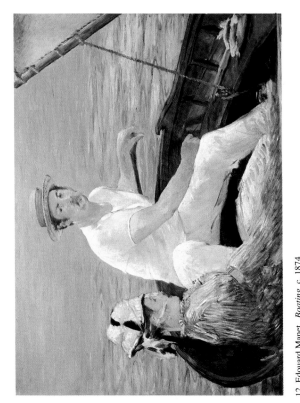

12. Edouard Manet *Boating* c. 1874
The Metropolitan Museum of Art, New York: The H. O. Havemeyer Collection

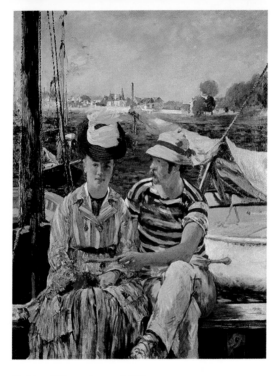

13. Edouard Manet *Argenteuil,* 1874
Musée des Beaux-Arts, Tournai, Belgium; Collection H. von Cutson

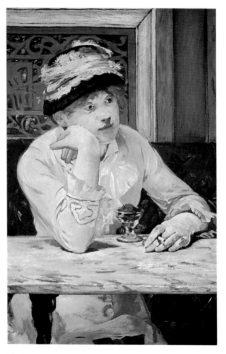

14. Edouard Manet *The Plum,* c. 1877
National Gallery of Art, Washington, D.C.;
Collection of Mr. and Mrs. Paul Mellon

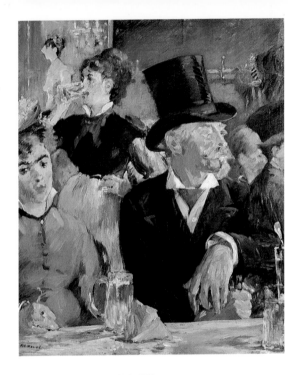

15. Edouard Manet *At the Café*, 1878
Walters Art Gallery, Baltimore

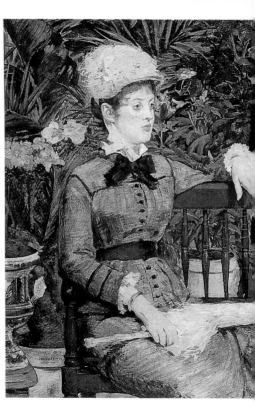

16. Edouard Manet
In the Conservatory, 1879
Nationalgalerie, Berlin

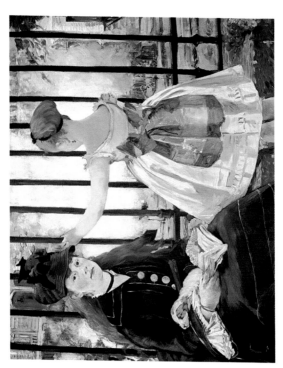

17. Edouard Manet *Gare St.-Lazare (Le Chemin de fer)*, 1873
National Gallery of Art, Washington, D.C.;
Gift of Horace Havemeyer in memory of his mother, Louisine Havemeyer

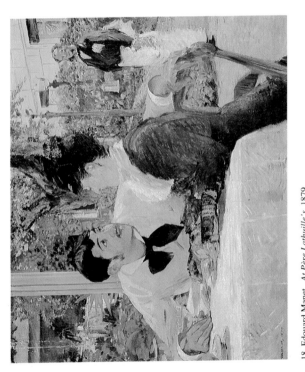

18. Edouard Manet *At Père Lathuille's*, 1879
Musée des Beaux-Arts, Tournai, Belgium

19. Edouard Manet *Portrait of Alphonse Maureau*, c. 1880
Art Institute of Chicago; Gift of Kate L. Brewster

20. Edouard Manet *Le Journal Illustré*, c. 1878–79
Art Institute of Chicago; Mr. and Mrs. Lewis L. Coburn
Memorial Collection

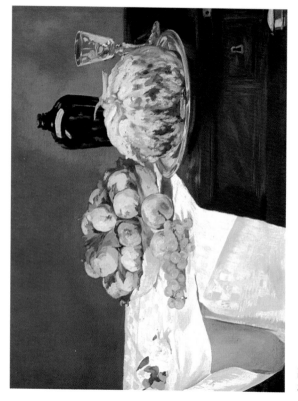

21. Edouard Manet *Still Life with Melon and Peaches*, 1866
National Gallery of Art, Washington, D.C.: Gift of Eugene and Agnes Meyer

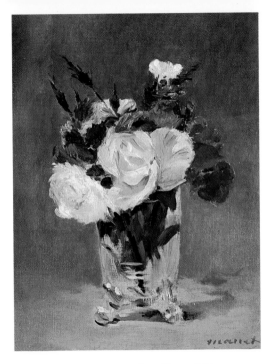

22. Edouard Manet *Flowers in a Crystal Vase*, c. 1882
National Gallery of Art, Washington, D.C.;
Ailsa Mellon Bruce Collection

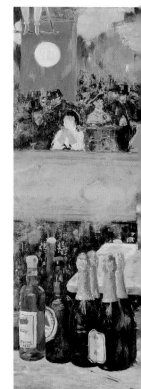

23. Edouard Manet
A Bar at the Folies Bergère, 1882
Courtauld Institute Galleries, London

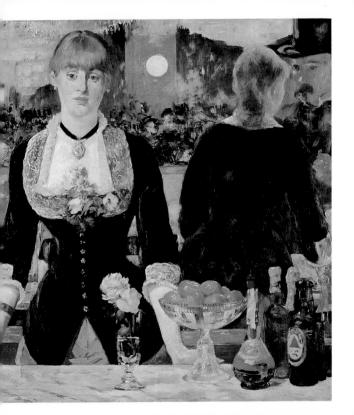

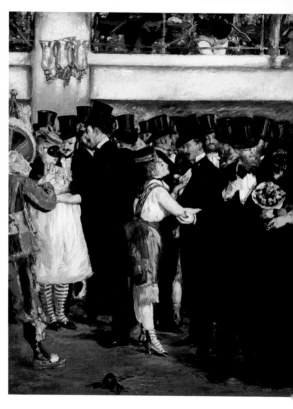

24. Edouard Manet *Le Bal de l'opéra,* 1873
National Gallery of Art, Washington, D.C.

THE NEW PAINTING

The seeds that had been planted in the minds of Bazille, Sisley, and Monet at the time of Manet's one-man exhibition in 1867 bore spectacular fruit seven years later with the first of eight collective exhibitions to be held in Paris between 1874 and 1886. Joined by Degas, Pissarro, Renoir, Guillaumin, Morisot, Cézanne, Boudin, and Bracquemond in founding a group incongruously called the *Société anonyme des peintres, sculpteurs, graveurs, etc.*, these artists were to enlist about thirty participants for the first Impressionist exhibition in 1874.

In the press there was the inevitable virulent reaction to the "radical" and audacious nature of the Impressionists' works, especially when viewed in concert with those shown in the official Salon of that year. What the painters of the Academy would consider preparatory sketches, the Impressionists unashamedly exhibited as completed works for public display and admiration. But these young artists (mostly in their thirties) would not be denied, and they only temporarily had to lick their wounds from the critics. They were jointly preoccupied with atmosphere, water, and other evanescent effects, the flickering of light on a summer's day, rippling breezes, boating parties, dances, and all the common pleasures of man.

Thus, this "new" painting with contemporary life as its theme, reflecting a significant alteration in its pace, dwelling as it did in the activities of society at all levels, and imbued with an openness heretofore not known, might actually have been given a toehold by the Academy when it extended landscape painting a nod of approval more than a half century earlier.

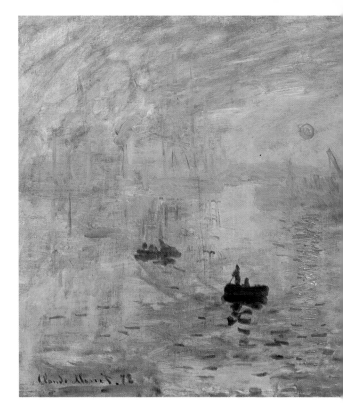
Claude Monet. 72

1. Claude Monet *Impression, Sunrise,* c. 1872
Musée Marmottan, Paris

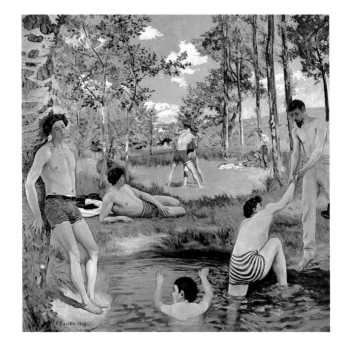

2. Frédéric Bazille *Bathers (Scene d'eté),* 1869
Fogg Museum, Harvard University, Cambridge, Mass.;
Gift of M. and Mme. F. Meynier de Salinelles

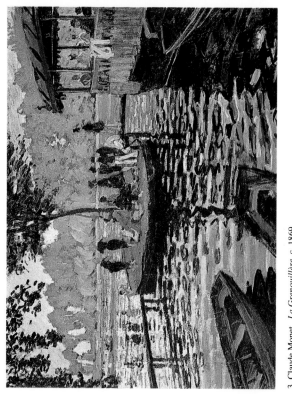

3. Claude Monet *La Grenouillère*, c. 1869
The Metropolitan Museum of Art, New York; The H. O. Havemeyer Collection

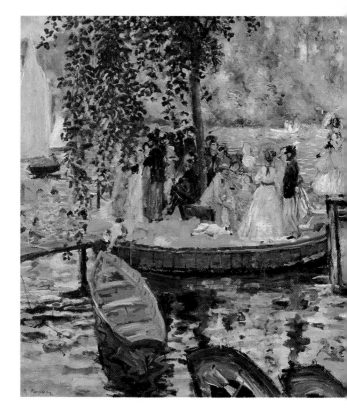

4. Pierre-Auguste Renoir *La Grenouillère,* c. 1869
National Museum, Stockholm

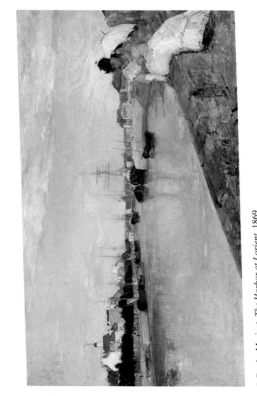

5. Berthe Morisot *The Harbor at Lorient*, 1869
National Gallery of Art, Washington, D.C.: Ailsa Mellon Bruce Collection

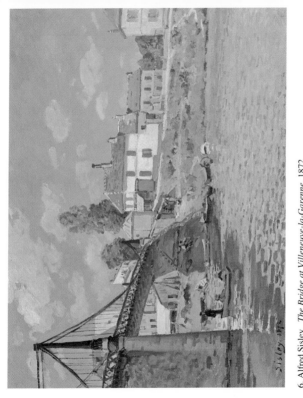

6. Alfred Sisley *The Bridge at Villeneuve-la-Garenne*, 1872
The Metropolitan Museum of Art, New York: Gift of Mr. and Mrs. Henry Ittleson, Jr.

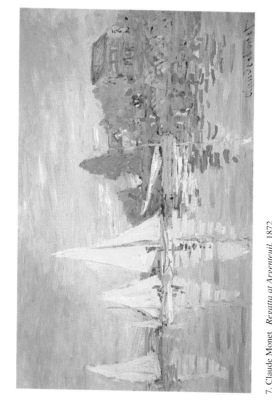

7. Claude Monet *Regatta at Argenteuil*, 1872
Musée D'Orsay, Paris

8. Alfred Sisley *Village Street in Marlotte*, 1866
Albright-Knox Art Gallery, Buffalo; General Purchase Fund

9. Edgar Degas
Carriage at the Races,
1871–72. Museum of
Fine Arts, Boston;
Arthur Gordon Tompkins
Residuary Fund

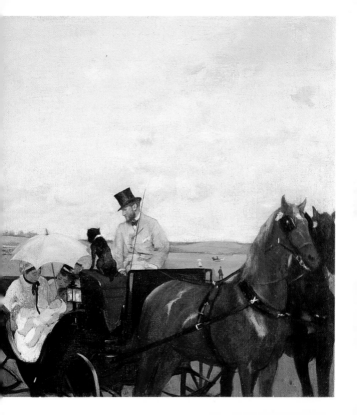

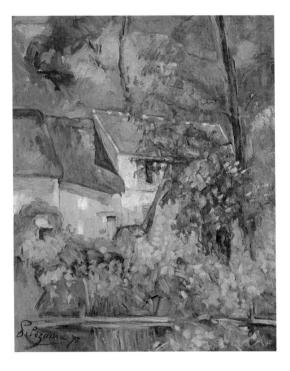

10. Paul Cézanne *House of Père Lacroix,* 1873
National Gallery of Art, Washington, D.C.; Chester Dale Collection

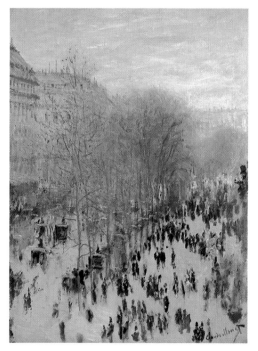

11. Claude Monet *Boulevard des Capucines,* 1873
Nelson Gallery, Atkins Museum, Kansas City;
Acquired through the Kenneth A. and Helen F. Spencer Foundation

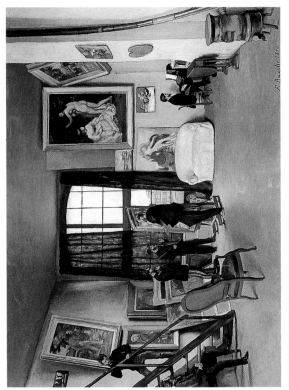

12. Frédéric Bazille *The Artist's Studio*, 1870
Musée D'Orsay, Paris

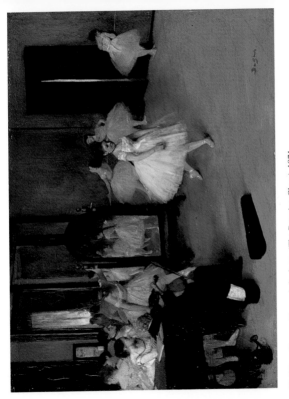

13. Edgar Degas *Foyer de la danse (The Dancing Class)*, 1871
The Metropolitan Museum of Art, New York; The H. O. Havemeyer Collection

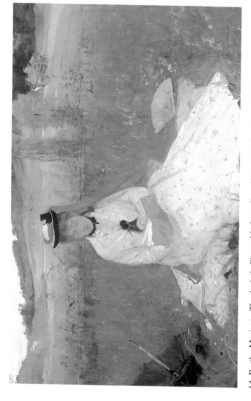

14. Berthe Morisot *The Artist's Sister, Madame Pontillon, Seated on Grass,* 1873
The Cleveland Museum of Art; Gift of Hanna Fund

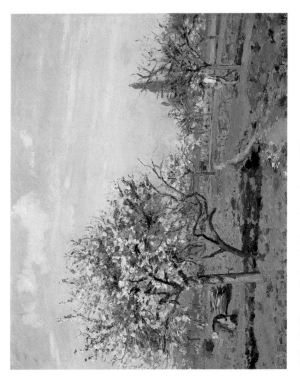

15. Camille Pissarro *Orchard in Bloom, Louveciennes*, 1872
National Gallery of Art, Washington, D.C.; Ailsa Mellon Bruce Collection

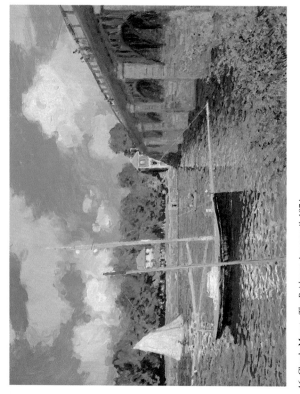

16. Claude Monet *The Bridge at Argenteuil*, 1874
National Gallery of Art, Washington, D.C.; Paul Mellon Collection

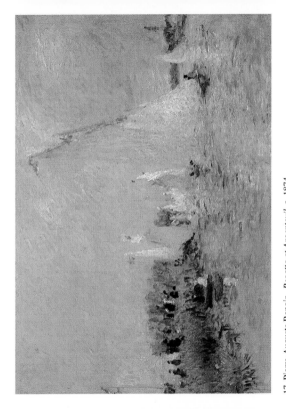

17. Pierre-Auguste Renoir *Regatta at Argenteuil*, c. 1874
National Gallery of Art, Washington, D.C.; Ailsa Mellon Bruce Collection

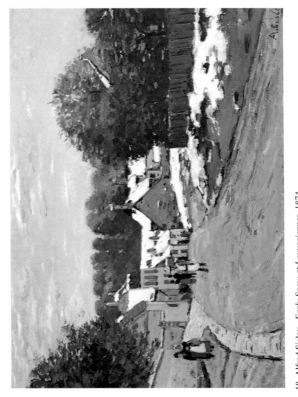

18. Alfred Sisley *Early Snow at Louveciennes*, 1874
Museum of Fine Arts, Boston; Bequest of John T. Spaulding

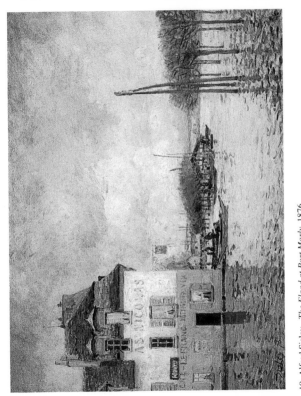

19. Alfred Sisley *The Flood at Port Marly*, 1876
Musée D'Orsay, Paris

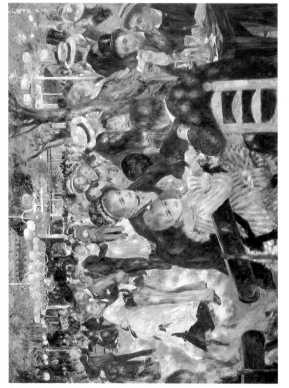

20. Pierre-Auguste Renoir *Dancing at the Moulin de la Galette*, 1876
Musée D'Orsay, Paris

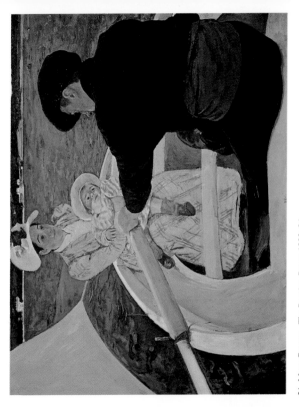

21. Mary Cassatt *The Boating Party*, 1893–94
National Gallery of Art, Washington, D.C.: Chester Dale Collection

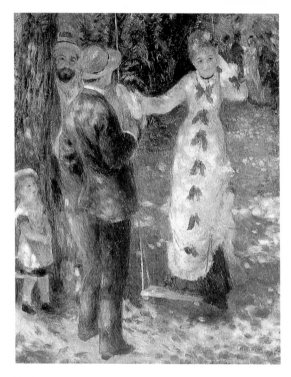

22. Pierre-Auguste Renoir *La Balançoire*, 1876
Musée D'Orsay, Paris

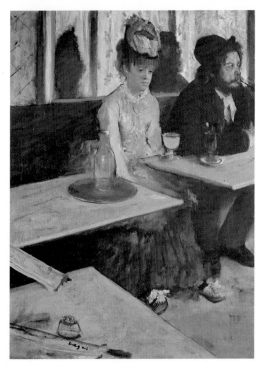

23. Edgar Degas *L'Absinthe,* 1876
Musée D'Orsay, Paris

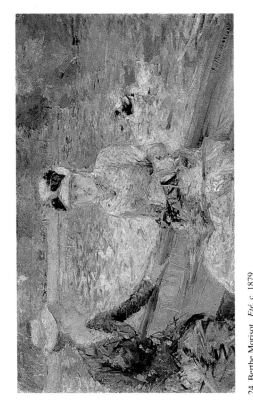

24. Berthe Morisot *Eté*, c. 1879

25. Edgar Degas *Portrait of Duranty,* 1879
Glasgow Art Gallery; The Burrell Collection

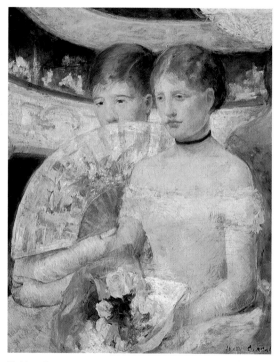

26. Mary Cassatt *The Loge,* 1882
National Gallery of Art, Washington, D.C.; Chester Dale Collection

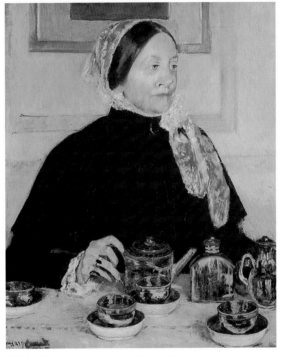

27. Mary Cassatt *Lady at the Tea Table,* 1885
The Metropolitan Museum of Art, New York; Gift of Mary Cassatt

CLAUDE MONET:

Impressionist par Excellence

Although Monet automatically comes to mind as the consummate Impressionist, he, like Manet, did not initially make an attempt to cast aside tradition and its route to success. He caught the eye of Boudin while a teenager in Le Havre, where he was exploring the ports and beaches and painting clouds and atmospheric effects. Boudin encouraged him in his interest in plein-air painting and urged him to visit Paris, where he enrolled in the atelier of history painter Charles Gleyre in 1862. In 1865 two of his seascapes were accepted by the official Salon.

Like Manet, Monet had utilized the time-honored theme of placing figures within a landscape, but he chose purely contemporary picnic scenes rather than a mixture of contemporary with allegory or mythology. And although, especially in his early career, he drew and worked on oil sketches directly from nature, he often integrated the various motifs captured into a finished composition back in his studio.

With the rejection of his works for the Salons of 1869 and 1870 came the realization that it was useless for him to seek further recognition through the existing art "establishment." In a sense this freed him from the academy forever, which was reinforced in London during the Franco-Prussian war, where he worked with Pissarro and became acquainted with the watercolors of Turner and Constable.

Back in France in 1871 and living in Argenteuil, he began his long struggle for financial stability and recognition, working directly with Sisley, Renoir, and Manet. It was in Argenteuil that he painted the numerous small works that have shaped our image of the exuberant, pleasure-filled world of the Impressionists.

In Paris from 1876 to 1878, Monet concentrated on the effects of the ever-changing urban world, but it was in the country that Monet felt most comfortable. In the 1880s and later at Giverny (where he would live for the rest of his life) he devoted much of his work to the pure effects of nature. He drew on his experience as a plein-air painter to expand the varieties of expression inherent in single motifs—haystacks, trees, the Rouen Cathedral, the garden at Giverny, and water lilies.

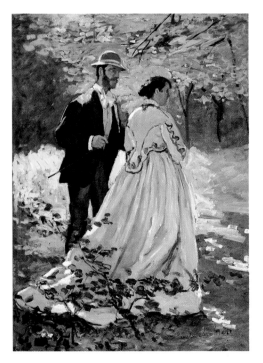

1. Claude Monet *Bazille and Camille,* 1865
National Gallery of Art, Washington, D.C.;
Ailsa Mellon Bruce Collection

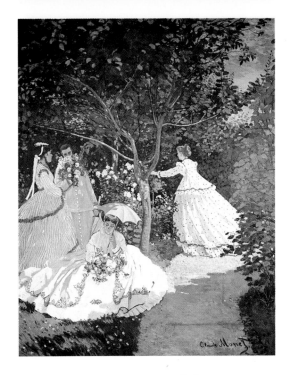

2. Claude Monet *Women in the Garden*, 1866–67
Musée D'Orsay, Paris

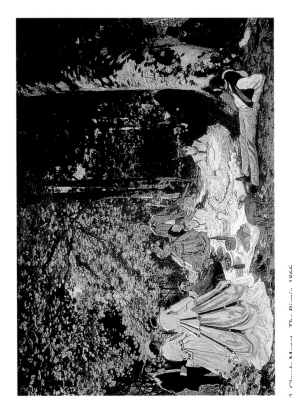

3. Claude Monet *The Picnic*, 1866
Pushkin Museum, Moscow

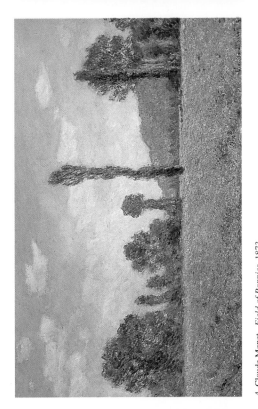

4. Claude Monet. *Field of Poppies*, 1873
Musée D'Orsay, Paris

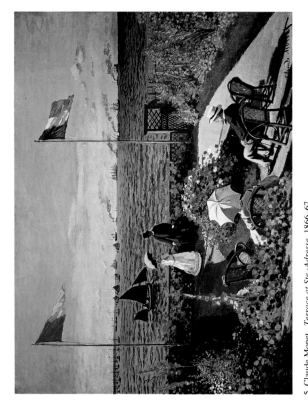

5. Claude Monet *Terrace at Ste.-Adresse,* 1866–67
The Metropolitan Museum of Art, New York; Friends of the Museum Fund

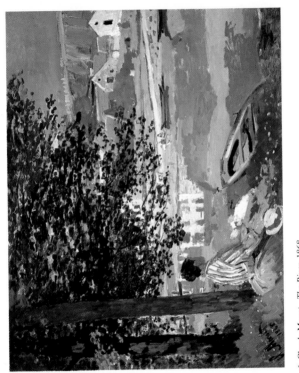

6. Claude Monet *The River*, 1868
Art Institute of Chicago; Potter Palmer Collection

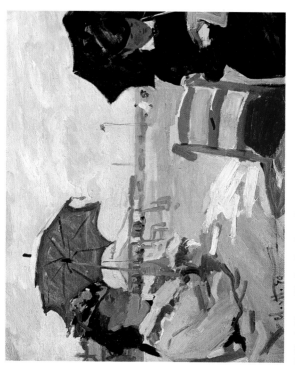

7. Claude Monet *The Beach at Trouville*, 1870

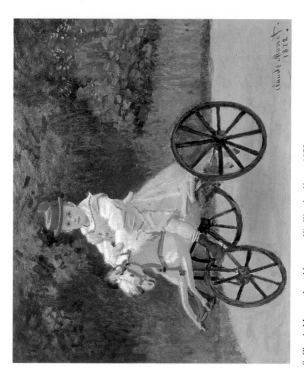

8. Claude Monet *Jean Monet on His Wooden Horse*, 1872
Nathan Cummings Collection, New York

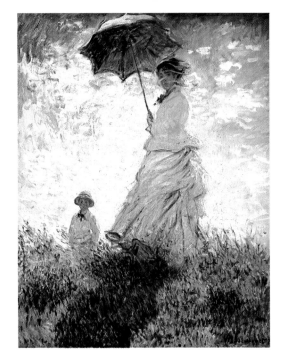

9. Claude Monet *Woman with a Parasol: Madame Monet
and Her Son,* 1875. National Gallery of Art, Washington, D.C.;
Collection of Mr. and Mrs. Paul Mellon

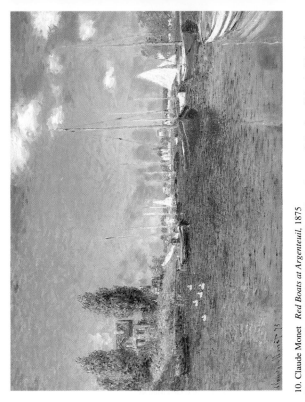

10. Claude Monet *Red Boats at Argenteuil*, 1875
Fogg Museum, Harvard University, Cambridge, Mass.; Bequest-Collection of Maurice Wertheim

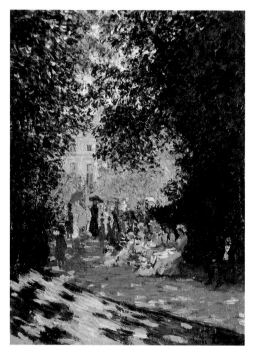

11. Claude Monet *Parisians Enjoying the Parc Monceau,* 1878
The Metropolitan Museum of Art, New York;
Mr. and Mrs. Henry Ittleson, Jr., Fund

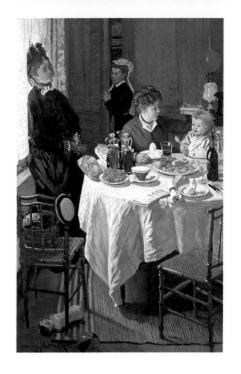

12. Claude Monet *The Luncheon,* 1868
Stadelsches Kunstinstitut, Frankfurt am Main

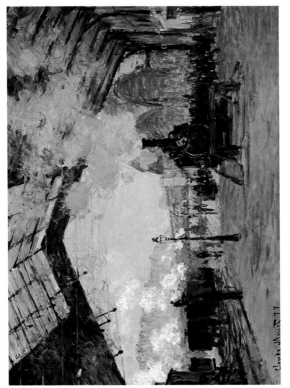

13. Claude Monet *St.-Lazare Station: The Arrival of the Train from Normandy*, 1877
Art Institute of Chicago; Mr. and Mrs. Martin A. Ryerson Collection

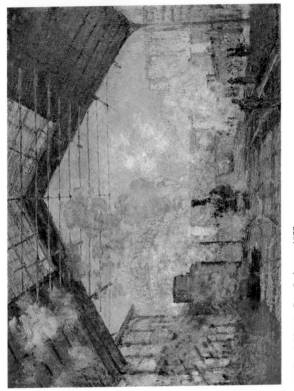

14. Claude Monet *Gare St.-Lazare*, 1877
Musée D'Orsay, Paris

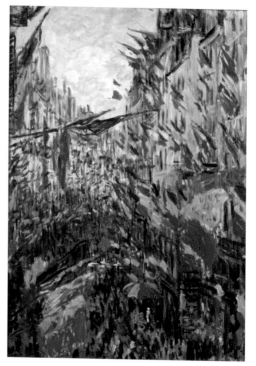

15. Claude Monet *Rue Saint-Denis*, 1878
Musée des Beaux-Arts, Rouen

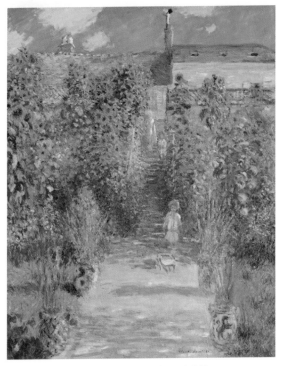

16. Claude Monet *The Artist's Garden at Vétheuil*, 1880
National Gallery of Art, Washington, D.C.: Ailsa Mellon Bruce Collection

17. Claude Monet *Bordighera*, 1884
Art Institute of Chicago; Potter Palmer Collection

18. Claude Monet *Bordighera,* 1884
Santa Barbara Museum of Art; Estate of Katherine Dexter McCormick

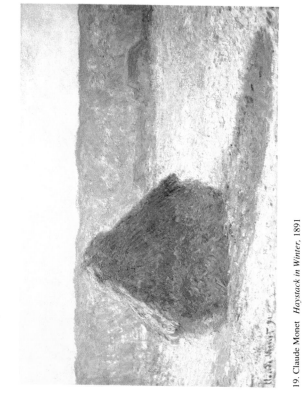

19. Claude Monet *Haystack in Winter*, 1891
Museum of Fine Arts, Boston; Gift of the Misses Aimee and Rosamond Lamb
in memory of Mr. and Mrs. Horatio A. Lamb

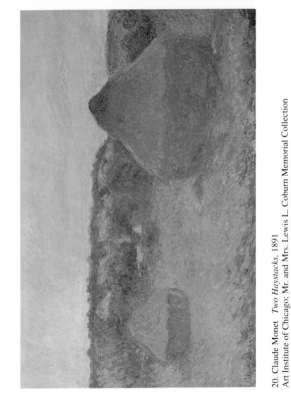

20. Claude Monet *Two Haystacks*, 1891
Art Institute of Chicago; Mr. and Mrs. Lewis L. Coburn Memorial Collection

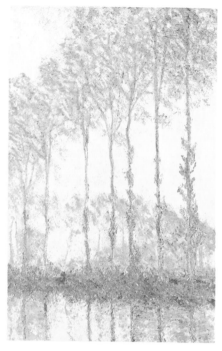

21. Claude Monet *Poplars on the Bank of the Epte River,*
1891. Philadelphia Museum of Art;
Bequest of Anne Thomson

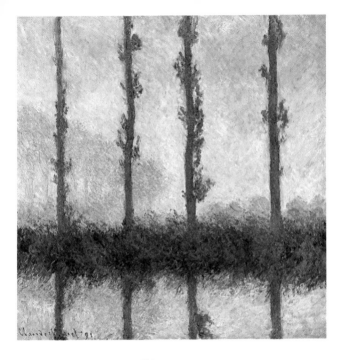

22. Claude Monet *The Poplars,* 1891
The Metropolitan Museum of Art, New York;
The H. O. Havemeyer Collection

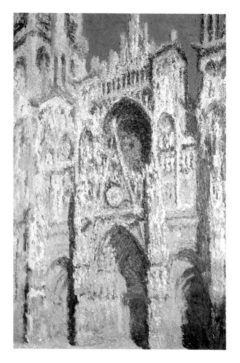

23. Claude Monet *Rouen Cathedral, Portal and Albane Tower,* 1894. Musée D'Orsay, Paris

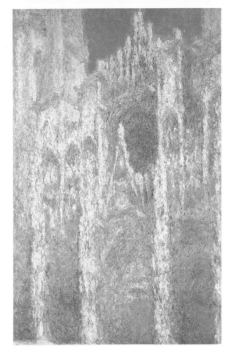

24. Claude Monet *Rouen Cathedral, Sunset,* 1894
Museum of Fine Arts, Boston;
Julia Cheney Edwards Collection

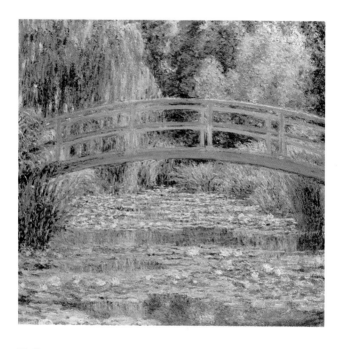

25. Claude Monet *The Japanese Footbridge and the Water Lily Pond, Giverny*, 1899
Philadelphia Museum of Art; The Mr. and Mrs. Carroll S. Tyson Collection

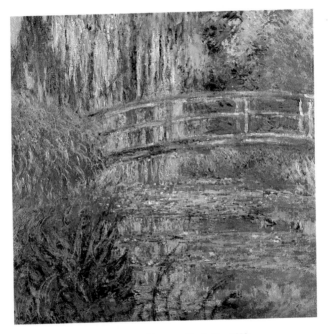

26. Claude Monet *Water Garden and Japanese Footbridge*, 1900
Museum of Fine Arts, Boston; Given in memory of
Governor Alvan T. Fuller by the Fuller Foundation

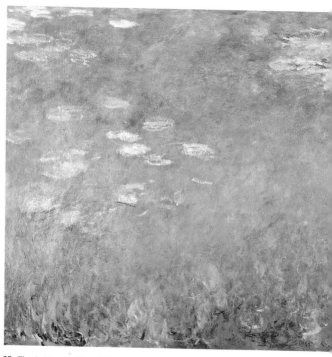

27. Claude Monet *Water Lilies I*, 1905
Museum of Fine Arts, Boston; Gift of Edward Jackson Holmes

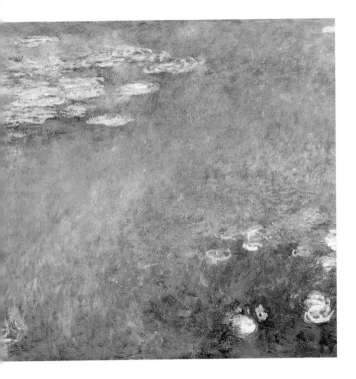

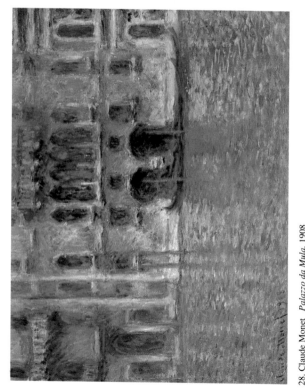

28. Claude Monet *Palazzo da Mula*, 1908
National Gallery of Art, Washington, D.C.; Chester Dale Collection

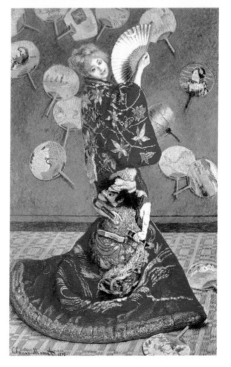

29. Claude Monet *La Japonaise,* 1876
Museum of Fine Arts, Boston; 1951 Purchase Fund

PIERRE-AUGUSTE RENOIR:

The Exuberant Impressionist

For Renoir, painting was first and foremost a source of pleasure. His early experience had included copying the sensuous and romantic works of the Rococo era, and this influenced the themes of his mature years. His formal training began at the Ecole des Beaux-Arts in the studio of Gleyre. He was often at odds with his master, who, essentially a history painter, viewed painting as serious and didactic.

In August 1869 Renoir worked side-by-side with Monet at La Grenouillère, and there his first recognizably Impressionist works were painted, derived in part from his exposure to Monet's juxtaposition of broad, rapid strokes of color. In 1872 and 1874 he again painted with Monet, but this time at Argenteuil, followed by a period in Montmartre where he concentrated on figurative studies of his fellow artists and such places of merriment as the Moulin de la Galette. His essential purpose was less to capture the fleeting moment than it was to communicate a certain social milieu.

Despite his seeming adherence to plein-air themes, he became increasingly restless to move from the broken color and ephemeral immediacy of Impressionism. Visiting Italy in the autumn of 1881 and inspired by the masters of the High Renaissance, he developed a renewed interest and enthusiasm for the art of the past. From that point on, his zest for painting was more and more concentrated on the female nude, with a firmness reminiscent of Ingres, but with the lessons of Impressionism clearly in evidence.

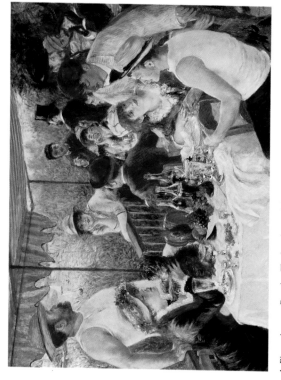

1. Pierre-Auguste Renoir *The Luncheon of the Boating Party*, 1881
The Phillips Collection, Washington, D.C.

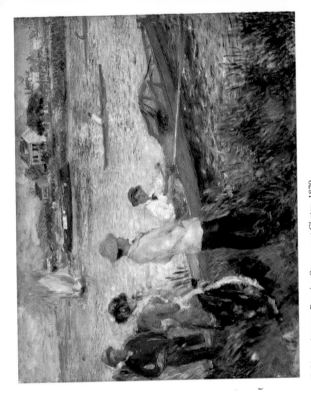

2. Pierre-Auguste Renoir *Oarsmen at Chatou*, 1879
National Gallery of Art, Washington, D.C.; Gift of Sam. A. Lewisohn

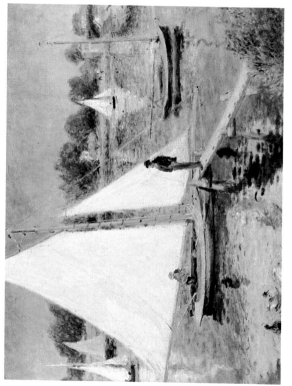

3. Pierre-Auguste Renoir *Sailboats at Argenteuil*, 1873–74
Portland Art Museum, Oregon

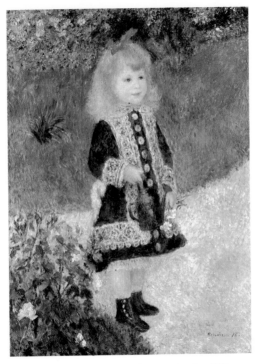

4. Pierre-Auguste Renoir *A Girl with a Watering Can,* 1876
National Gallery of Art, Washington, D.C.; Chester Dale Collection

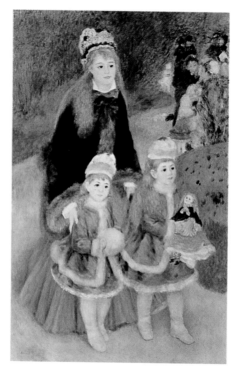

5. Pierre-Auguste Renoir *Mother and Children*, c. 1874–76
The Frick Collection, New York

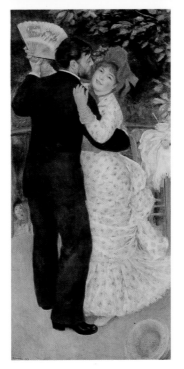

6. Pierre-Auguste Renoir *Dance in the Country*, 1883. Musée D'Orsay, Paris

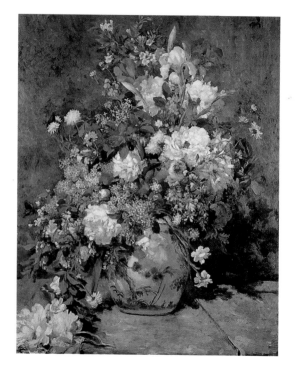

7. Pierre-Auguste Renoir *Spring Bouquet,* 1866
Fogg Museum, Harvard University, Cambridge, Mass.

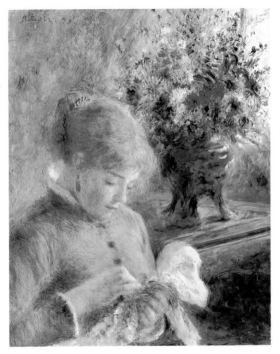

8. Pierre-Auguste Renoir *Young Woman Sewing*, 1879
Art Institute of Chicago; Mr. and Mrs. Lewis L. Coburn
Memorial Collection

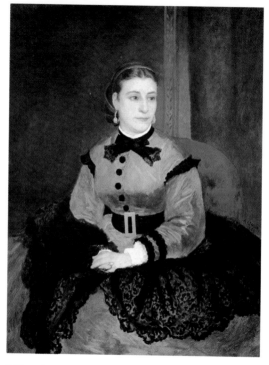

9. Pierre-Auguste Renoir *Mademoiselle Sicot,* 1865
National Gallery of Art, Washington, D.C.; Chester Dale Collection

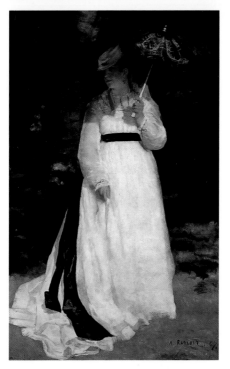

10. Pierre-Auguste Renoir *Lise with a Parasol*, 1867
Museum Folkwang, Essen

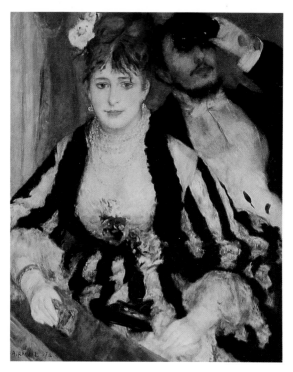

11. Pierre-Auguste Renoir *La Loge,* 1874
Courtauld Institute Galleries, London

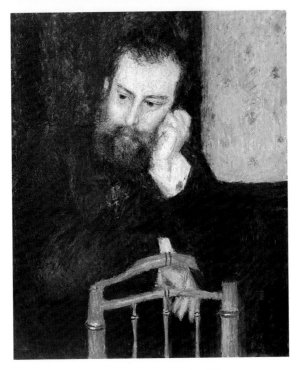

12. Pierre-Auguste Renoir *Portrait of Alfred Sisley,* 1874
Art Institute of Chicago; Mr. and Mrs. Lewis L. Coburn Memorial Collection

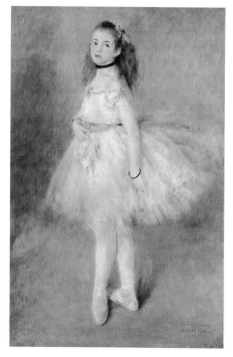

13. Pierre-Auguste Renoir *The Dancer,* 1874
National Gallery of Art, Washington, D.C.;
Widener Collection

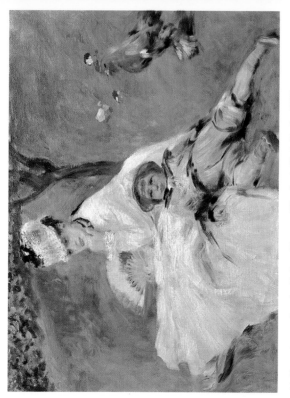

14. Pierre-Auguste Renoir *Madame Monet and Her Son in Their Garden*, 1874
National Gallery of Art, Washington, D.C.; Ailsa Mellon Bruce Collection

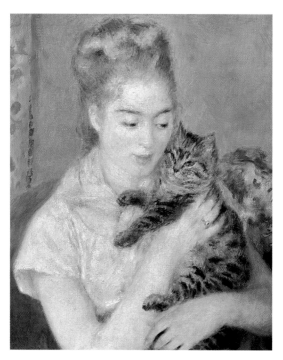

15. Pierre-Auguste Renoir *Woman with a Cat*, c. 1875
National Gallery of Art, Washington, D.C.;
Gift of Mr. and Mrs. Benjamin Levy

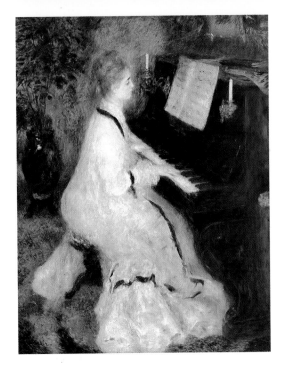

16. Pierre-Auguste Renoir *Lady at the Piano*, c. 1875–76
Art Institute of Chicago; Mr. and Mrs. Martin A. Ryerson Collection

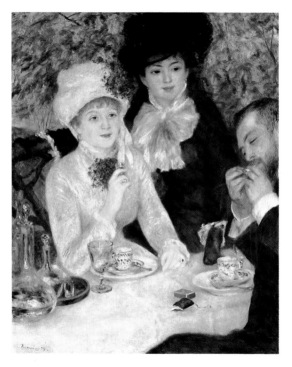

17. Pierre-Auguste Renoir *Le Déjeuner,* 1879
Stadelsches Kunstinstitut, Frankfurt

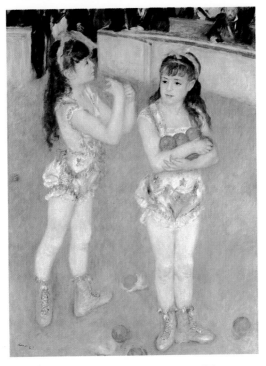

18. Pierre-Auguste Renoir *Two Little Circus Girls*, 1879
Art Institute of Chicago; Potter Palmer Collection

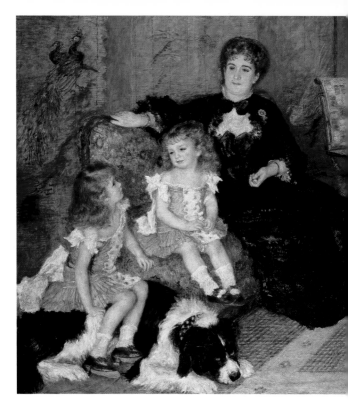

19. Pierre-Auguste Renoir *Madame Charpentier with Her Children, Georgette and Paul,* 1878
The Metropolitan Museum of Art, New York; Wolfe Fund, Catherine Lorillard Wolfe Collection

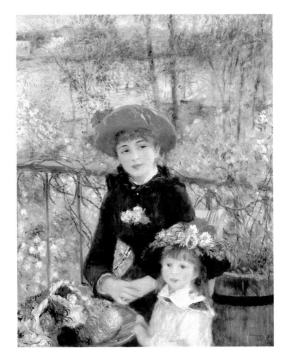

20. Pierre-Auguste Renoir *On the Terrace,* 1881
Art Institute of Chicago; Mr. and Mrs. Lewis L. Coburn
Memorial Collection

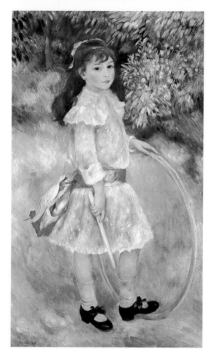

21. Pierre-Auguste Renoir *Girl with a Hoop,* 1885
National Gallery of Art, Washington, D.C.;
Chester Dale Collection

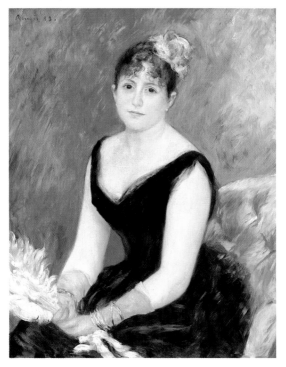

22. Pierre-Auguste Renoir *Madame Clapisson (Lady with a Fan)*, 1883
Art Institute of Chicago; Mr. and Mrs. Martin A. Ryerson Collection

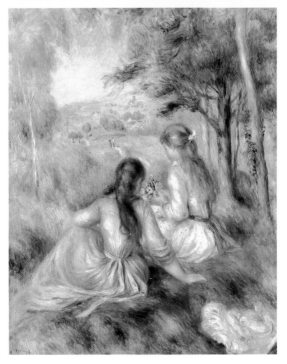

23. Pierre-Auguste Renoir *In the Meadow,* c. 1890
The Metropolitan Museum of Art, New York

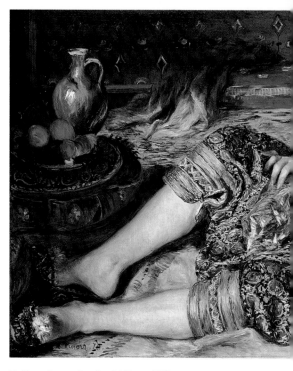

24. Pierre-Auguste Renoir *Odalisque,* 1870
National Gallery of Art, Washington, D.C.; Chester Dale Collection

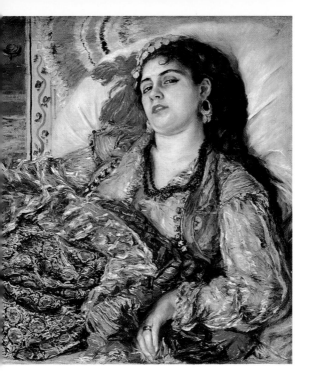

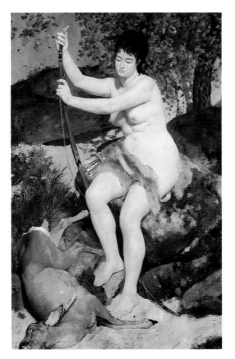

25. Pierre-Auguste Renoir *Diana,* 1867
National Gallery of Art, Washington, D.C.;
Chester Dale Collection

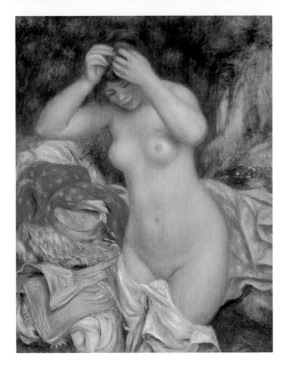

26. Pierre-Auguste Renoir *Bather Arranging Her Hair,* 1893
National Gallery of Art, Washington D.C.; Chester Dale Collection

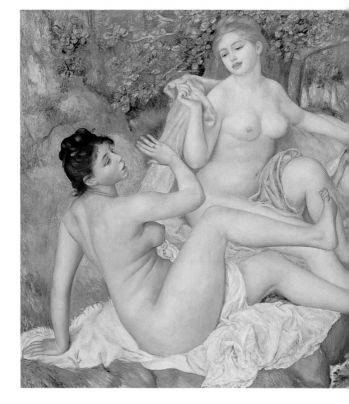

27. Pierre-Auguste Renoir
Bathers, 1887
Philadelphia Museum of Art

EDGAR DEGAS *and* HENRI DE TOULOUSE-LAUTREC:

The Studied Moment

These two artists shared a lack of interest in landscape themes (except for Degas's fascination with horses and racetracks); both concentrated on people, primarily women, and the play of artificial light in their "natural" environments. But beyond that, in the subjects they chose, their methodology, the company they kept, and their life experiences, there was very little connection between them or with the other Impressionists.

From the very beginning Degas abhorred being labeled an Impressionist and preferred to think of himself as a Realist, even as he participated in the first Impressionist group exhibition. While he believed in the value of studying nature, he insisted that the crucial factor in painting was the artist's mediating intelligence—the supremacy of the mind.

Degas's work displays concern for design and composition as well as psychological and social implications. He was not constrained by traditional conventions but followed his natural penchant for experimentation and unexpected juxtapositions (such as cut-off forms influenced by Japanese prints), as did Toulouse-Lautrec.

While Degas may have argued that all aspects of contemporary experience were worthy of artistic exploration, Toulouse-Lautrec carried this to its limiting case. And while Degas chose his subjects from the worlds of the ballet and theater, as well as that of the milliner or laundress, Toulouse-Lautrec favored more lurid themes. Crippled after a series of accidents in his early youth, Toulouse-Lautrec focused on the human form with exaggerations and distortions not seen in the work of any of his contemporaries.

Choosing a decidedly bohemian life, Toulouse-Lautrec came in contact with and painted the fleeting moments of low-class dancers, singers, prostitutes, and even small-time criminals. His work, although unique in subject at the time, included devices prevalent in Impressionism in general and in Degas's work in particular—concise design and color and a somewhat caustic summary of gesture and movement. To the end Toulouse-Lautrec professed not to belong to any group.

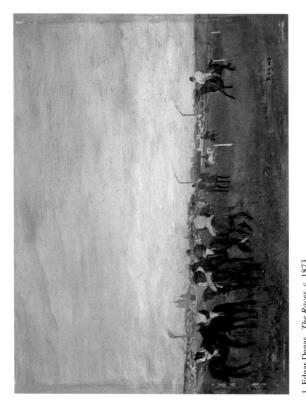

1. Edgar Degas *The Races*, c. 1873
National Gallery of Art, Washington, D.C.; Widener Collection

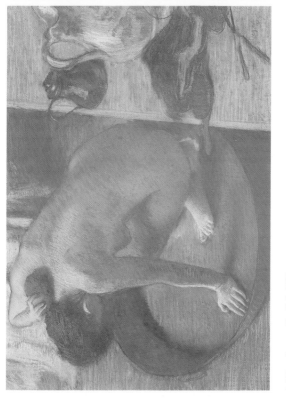

2. Edgar Degas *The Tub*, 1886
Musée D'Orsay, Paris

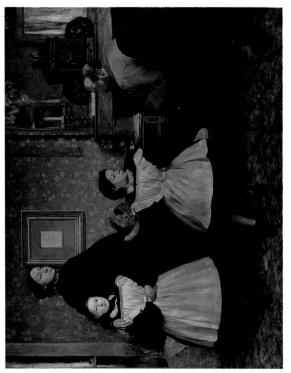

3. Edgar Degas *The Bellelli Family*, 1858–62
Musée D'Orsay, Paris

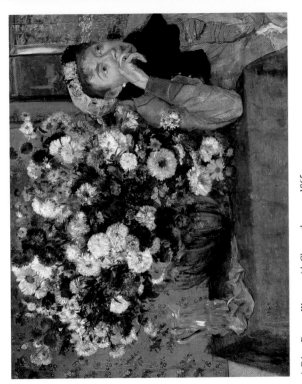

4. Edgar Degas *Woman with Chrysanthemums*, 1865
The Metropolitan Museum of Art, New York; The H. O. Havemeyer Collection

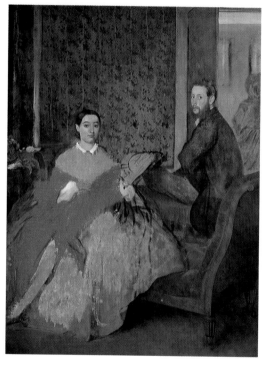

5. Edgar Degas *Edmondo and Thérèse Morbilli,* c. 1865
National Gallery of Art, Washington, D.C.; Chester Dale Collection

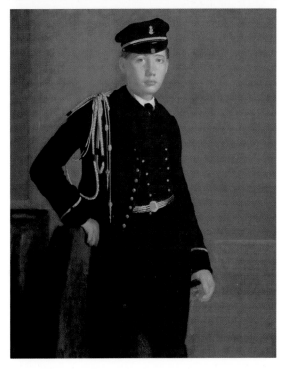

6. Edgar Degas *Achille de Gas in the Uniform of a Cadet,* 1856–57
National Gallery of Art, Washington, D.C.; Chester Dale Collection

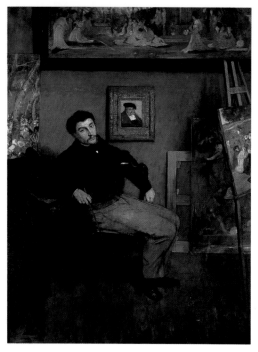

7. Edgar Degas *Jacques Joseph Tissot,* 1868
The Metropolitan Museum of Art, New York; Rogers Fund

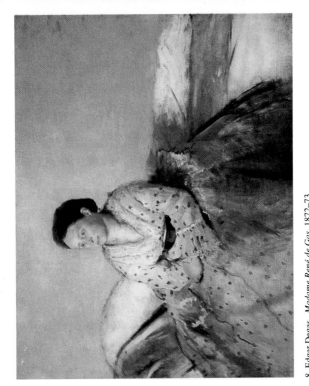

8. Edgar Degas *Madame René de Gas,* 1872–73
National Gallery of Art, Washington, D.C.: Chester Dale Collection

9. Edgar Degas *Madame Camus*, 1869–70
National Gallery of Art, Washington, D.C.; Chester Dale Collection

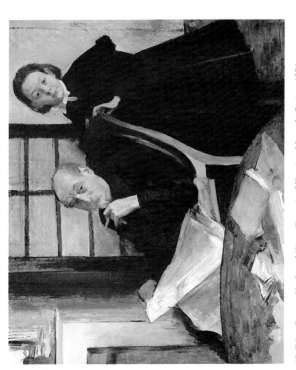

10. Edgar Degas *Uncle and Niece (Portrait of Henri and Lucy de Gas)*, c. 1876
Art Institute of Chicago; Mr. and Mrs. Lewis L. Coburn Memorial Collection

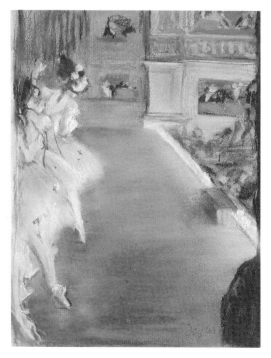

11. Edgar Degas *Dancers at the Old Opera House,* c. 1877
National Gallery of Art, Washington, D.C.;
Ailsa Mellon Bruce Collection

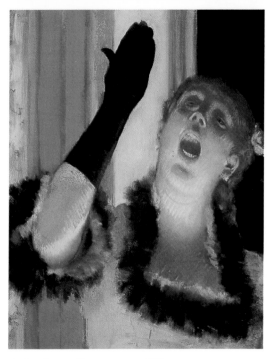

12. Edgar Degas *Chanteuse au gant,* 1878
Fogg Museum, Harvard University, Cambridge, Mass.;
Bequest-Collection of Maurice Wertheim

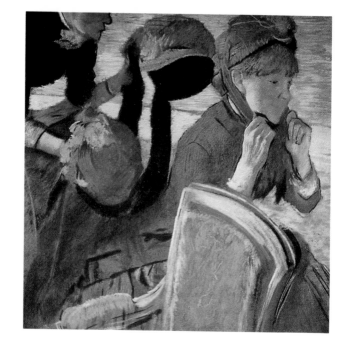

13. Edgar Degas *At the Milliner's*, c. 1882
Museum of Modern Art, New York; Gift of Mrs. David M. Levy

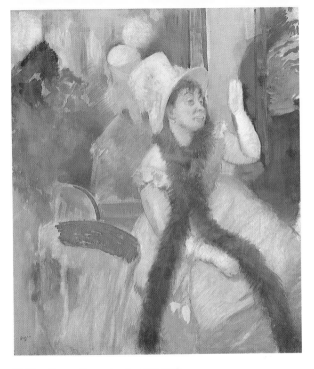

14. Edgar Degas *Woman in a Rose Hat,* 1879
Art Institute of Chicago; Joseph Winterbotham Collection

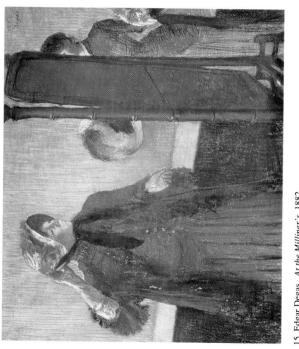

15. Edgar Degas *At the Milliner's*, 1882
The Metropolitan Museum of Art, New York; The H. O. Havemeyer Collection

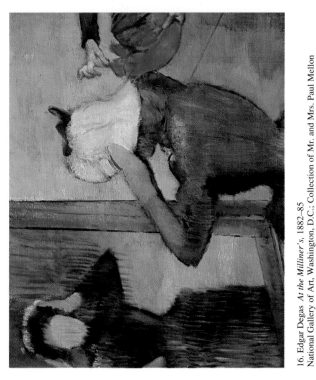

16. Edgar Degas *At the Milliner's*, 1882–85
National Gallery of Art, Washington, D.C.; Collection of Mr. and Mrs. Paul Mellon

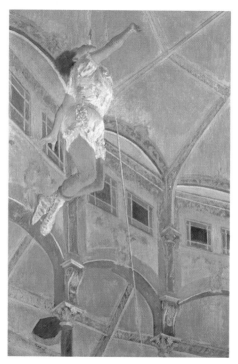

17. Edgar Degas *Miss Lala at the Circus Fernando,* 1879
National Gallery, London; Courtauld Collection

18. Edgar Degas *Four Dancers*, c. 1899
National Gallery of Art, Washington D.C.; Chester Dale Collection

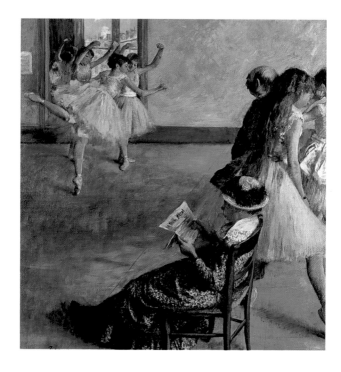

19. Edgar Degas *The Ballet Class,* c. 1880
Philadelphia Museum of Art; The W. P. Wilstach Collection

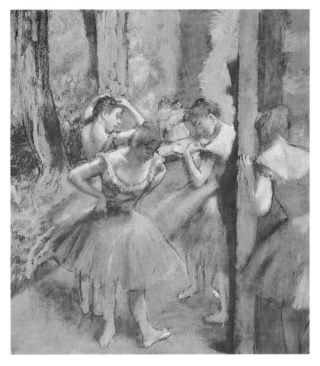

20. Edgar Degas *Dancers, Pink and Green,* c. 1890
The ·Metropolitan Museum of Art, New York; The H. O. Havemeyer Collection

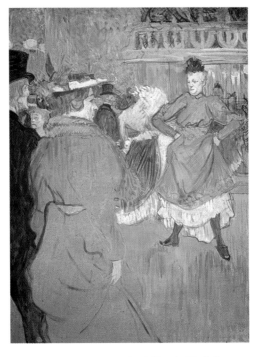

21. Henri de Toulouse-Lautrec *Quadrille at the Moulin Rouge,*
1892. National Gallery of Art, Washington, D.C.;
Chester Dale Collection

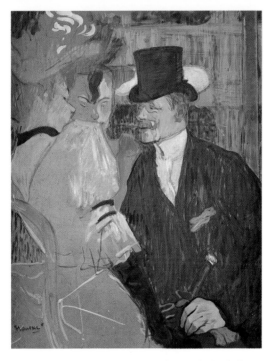

22. Henri de Toulouse-Lautrec *The Englishman at the Moulin Rouge,*
1892. The Metropolitan Museum of Art, New York;
Bequest of Miss Adelaide Milton de Groot

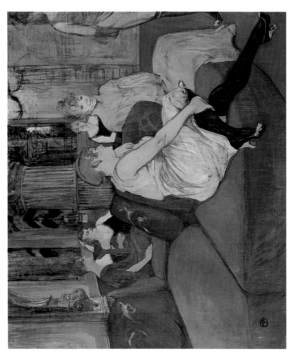

23. Henri de Toulouse-Lautrec *Au salon de la Rue des Moulins*, 1894
Musée Toulouse-Lautrec, Albi

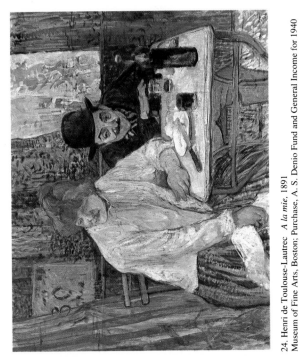

24. Henri de Toulouse-Lautrec *A la mie*, 1891
Museum of Fine Arts, Boston; Purchase, A. S. Denio Fund and General Income for 1940

25. Henri de Toulouse-Lautrec
In the Circus Fernando:
The Ringmaster, 1888
Art Institute of Chicago;
Joseph Winterbotham Collection

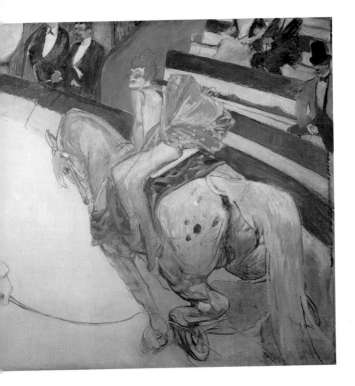

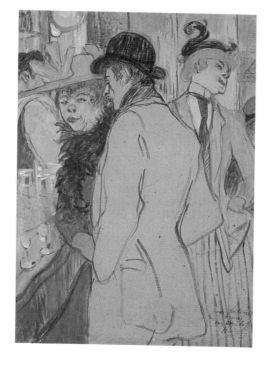

26. Henri de Toulouse-Lautrec *Alfred la Guigne,* 1894
National Gallery of Art, Washington, D.C.; Chester Dale Collection

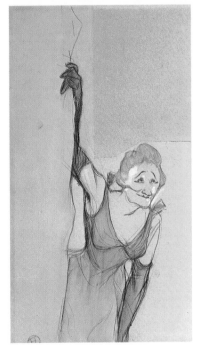

27. Henri de Toulouse-Lautrec *Yvette Guilbert
Taking a Curtain Call,* 1894. Rhode Island
School of Design; Gift of Mrs. William S. Dareforth

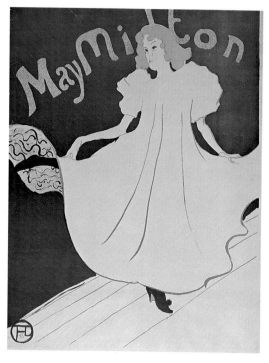

28. Henri de Toulouse-Lautrec *May Milton*, 1895
Art Institute of Chicago; Bequest of Kate L. Brewster

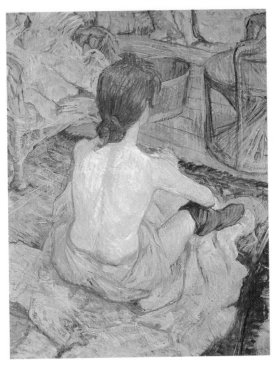

29. Henri de Toulouse-Lautrec *La Toilette*, 1896
Musée D'Orsay, Paris

THE IMPRESSIONISTS

IN 1886

In 1886 the eighth and last Impressionist exhibition was held, after a four-year hiatus, but missing were such pivotal Impressionists as Monet, Renoir, Sisley, and Caillebotte. Indeed, it was only through Pissarro's untiring efforts that it happened at all, and he seems to have been motivated chiefly by his interest in two young painters, Paul Signac and Georges Seurat. The showing of Seurat's *A Sunday Afternoon on the Island of La Grande Jatte* (1884–86) at the exhibition laid bare the "crisis" in Impressionism.

In fact, the challenge of *La Grande Jatte* resided precisely in the artist's choice of a familiar Impressionist plein-air theme as the point of departure for an entirely new method of applying color. In his attempt to relate painting to modern science, Seurat, as well as his followers Signac and Cross, were thus viewed as truly modern painters.

When Van Gogh arrived in Paris early in 1886, he was largely ignorant of the development of Impressionism. But with the peculiar urgency that marked both his personal life and his career as a painter, he quickly assimilated the essence of the movement and then challenged it. He immediately lightened his palette and changed his subject matter, but criticized Impressionist "sloppiness" and "superficiality." He moved to Arles in February 1888, and when he finally convinced Gauguin to join him he believed his dream of artistic collaboration would be fulfilled. But that was not to be.

Van Gogh's last troubled years are well known and documented, and his paintings of the time were often his most brilliant, but Gauguin had already moved on to Pont-Aven, Brittany, where contemporary life was imbued with centuries of tradition and religious fervor. The Symbolist style that Gauguin had developed there found an equally satisfying set of themes in the exoticism, folklore, and myths Gauguin later encountered in Tahiti, where he created his most expressive, mysterious, but most physical world, far removed from Impressionism.

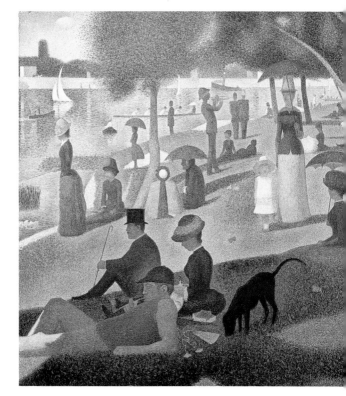

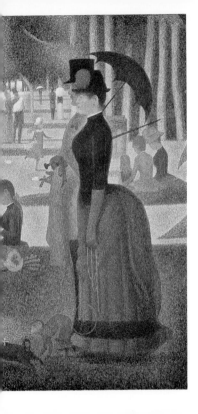

1. Georges Seurat *A Sunday
Afternoon on the Island of
La Grande Jatte,* 1884–86
Art Institute of Chicago; Helen
Birch Bartlett Memorial Collection

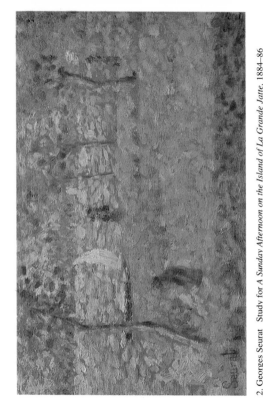

2. Georges Seurat Study for *A Sunday Afternoon on the Island of La Grande Jatte*, 1884–86
National Gallery of Art, Washington, D.C.; Ailsa Mellon Bruce Collection

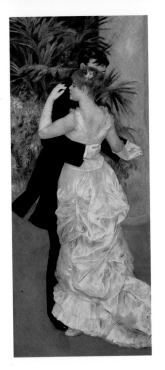

3. Pierre-Auguste Renoir *Dance in the City*, 1883. Musée D'Orsay, Paris

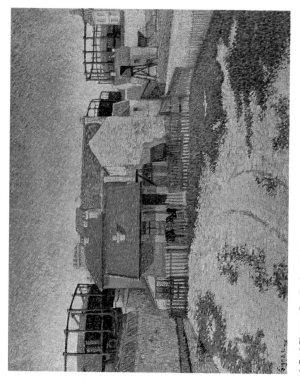

4. Paul Signac *Gas Tanks at Clichy*, 1886
National Gallery of Victoria, Melbourne; Felton Bequest

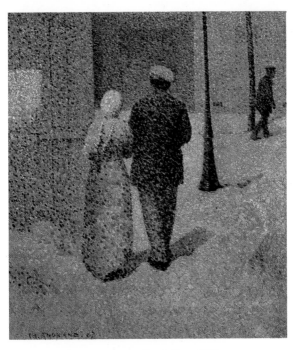

5. Charles Angrand *Man and Woman in the Street,* 1887
Musée National d'Art Moderne, Paris

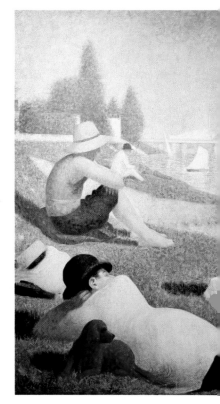

6. Georges Seurat
Bathers at Asnières, 1884
National Gallery, London

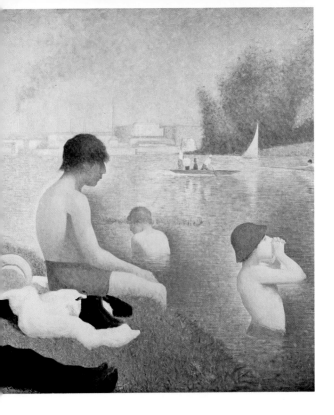

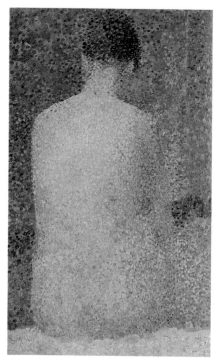

7. Georges Seurat *Model from the Back,* 1887
Musée D'Orsay, Paris

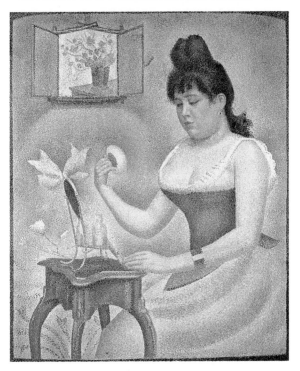

8. Georges Seurat *Woman Powdering Herself*, 1889–90
Courtauld Institute Galleries, London

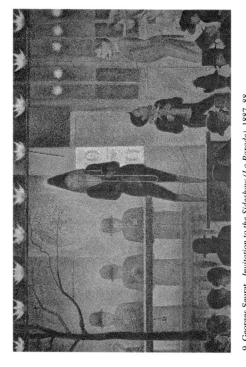

9. Georges Seurat *Invitation to the Sideshow (La Parade)*, 1887–88
The Metropolitan Museum of Art, New York

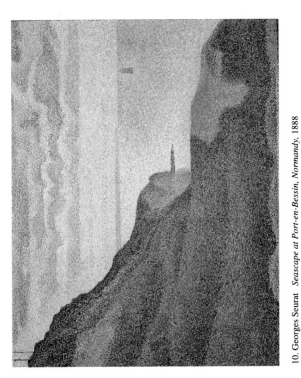

10. Georges Seurat *Seascape at Port-en-Bessin, Normandy*, 1888
National Gallery of Art, Washington, D.C.; Gift of the W. Averell Harriman Fund
in memory of Marie N. Harriman

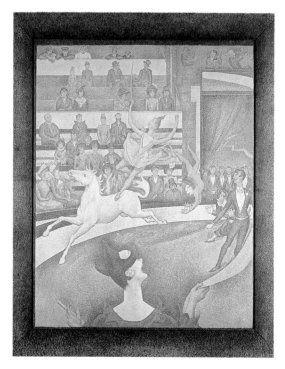

11. Georges Seurat *The Circus*, 1891
Musée D'Orsay, Paris

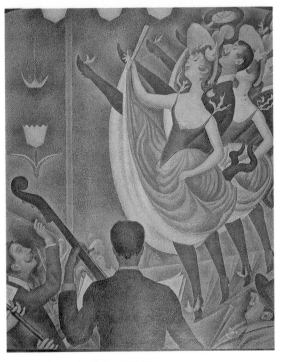

12. Georges Seurat *Le Chahut,* 1889–90
Rijksmuseum Kröller-Müller, Otterlo

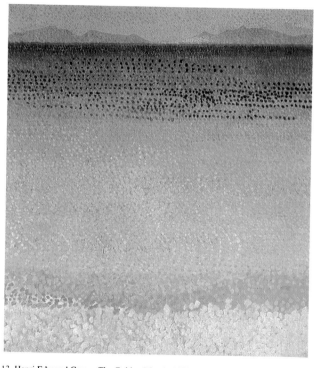

13. Henri Edmond Cross *The Golden Islands,* 1892
Musée National d'Art Moderne, Paris

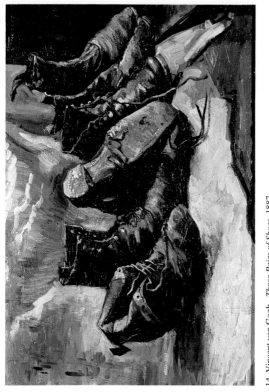

14. Vincent van Gogh *Three Pairs of Shoes*, 1887
Fogg Museum, Harvard University, Cambridge, Mass.; Collection of Maurice Wertheim

15. Vincent van Gogh *The Potato Eaters*, 1885
Rijksmuseum Vincent van Gogh, Amsterdam

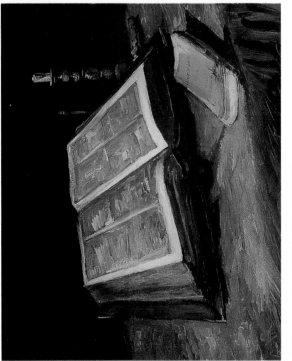

16. Vincent van Gogh *Still Life with the Bible,* 1885
Rijksmuseum Vincent van Gogh, Amsterdam

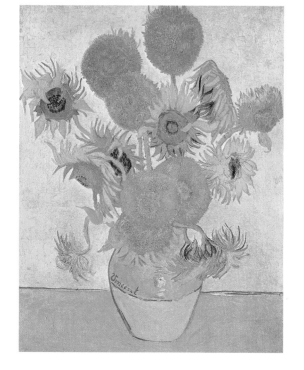

17. Vincent van Gogh *Sunflowers,* 1888
National Gallery, London

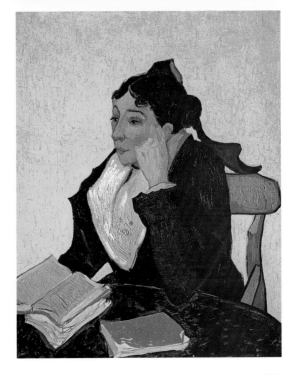

18. Vincent van Gogh *Portrait of Madame Ginoux (L'Arlésienne),* 1888
Metropolitan Museum of Art, New York; Samuel A. Lewisohn Bequest

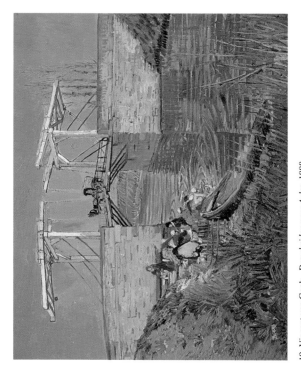

19. Vincent van Gogh *Drawbridge near Arles*, 1888
Rijksmuseum Kröller-Müller, Otterlo

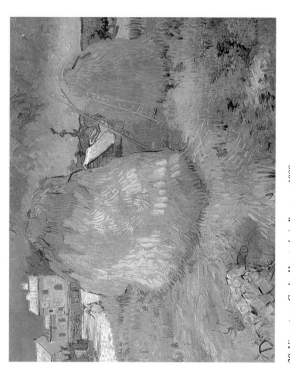

20. Vincent van Gogh *Haystacks in Provence*, 1888
Rijksmuseum Kröller-Müller, Otterlo

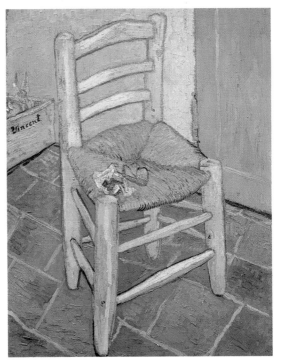

21. Vincent van Gogh *Van Gogh's Chair and Pipe,* 1888–89
The Tate Gallery, London

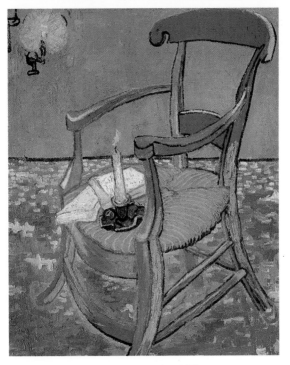

22. Vincent van Gogh *Gauguin's Armchair,* 1888
Rijksmuseum Vincent van Gogh, Amsterdam

23. Vincent van Gogh *The Night Café*, 1888
Yale University Art Gallery, New Haven; Gift of Stephen C. Clark

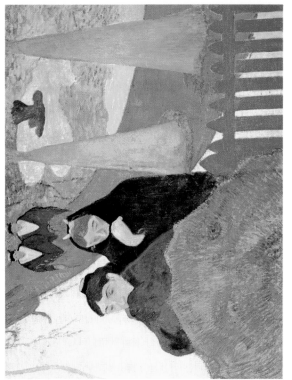

24. Paul Gauguin *Old Women of Arles*, 1888
Art Institute of Chicago; Gift of Annie Swan Coburn

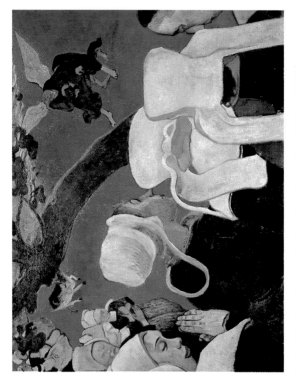

25. Paul Gauguin *Vision after the Sermon: Jacob Wrestling with the Angel*, 1888
National Galleries of Scotland, Edinburgh

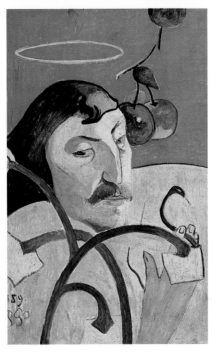

26. Paul Gauguin *Self-Portrait with Halo,* 1889
National Gallery of Art, Washington, D.C.;
Chester Dale Collection

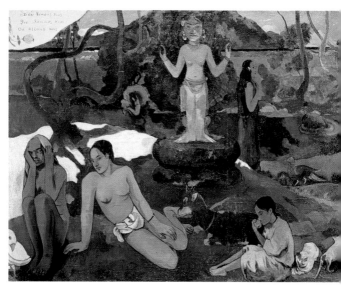

27. Paul Gauguin *D'où Venons Nou . . . Que Sommes Nous . . . Où Allons Nous?,*
1897. Museum of Fine Arts, Boston; Tompkins Collection

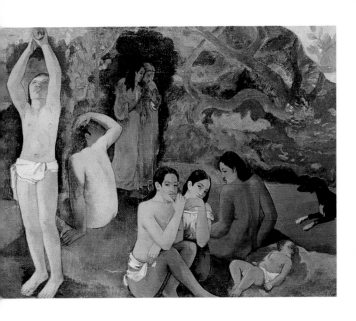

PAUL CEZANNE

and the Legacy of Impressionism

When Paul Cézanne moved to Paris in 1861, he spent hours sketching in the Louvre. He also worked at the Académie Suisse, where he met Pissarro, who later played a decisive role in his development as a landscape painter. Through his friendship with Emile Zola, he became acquainted with Manet, whose use of strong contrasts, opaque tones, and candid execution he found inspirational. Yet through the 1860s and 1870s Cézanne continued to paint visionary and erotic themes with mythological or religious connections.

In 1872 Cézanne joined Pissarro at Pontoise and later at Auvers, where he embarked on a serious study of landscape themes. He virtually abandoned anecdotal and mythological subjects, brightened his palette, changed the length and quantity of his brushstrokes, and participated in the first Impressionist exhibition in 1874.

In the third Impressionist exhibition (1877) Cézanne showed landscapes, but also one of his first paintings of bathers, a theme that enabled him to reconcile his attraction to the monumental art of the past and his new enthusiasm for landscape. Though a participant in the exhibitions of the Impressionists, Cézanne did not share their dedication to the fleeting moment and to effects of nature. Clarity, structure, and geometry in composition were the primary forces in Cézanne's work, giving it a sense of timelessness and solidity—a constructivist alternative to Impressionism.

His legacy is represented by two artists inspired by his work: Georges Braque and Pablo Picasso. With Picasso's *Les Demoiselles d'Avignon* (1907), we witness Cézanne's pictorial language in the process of further evolution. The tension between flat and solid forms, so often explored by Cézanne, has been taken and reworked into a new concept of space in which the formal integrity of objects is repeatedly violated by other objects and the space surrounding them; thus we have the birth of Cubism.

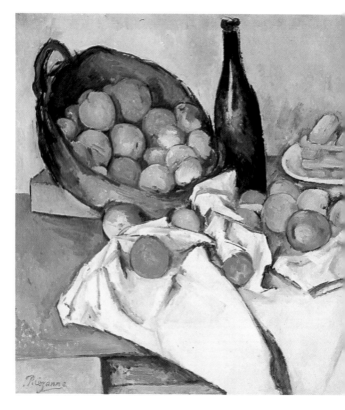

1. Paul Cézanne *The Basket of Apples*, c. 1895
Art Institute of Chicago; Helen Birch Bartlett Collection

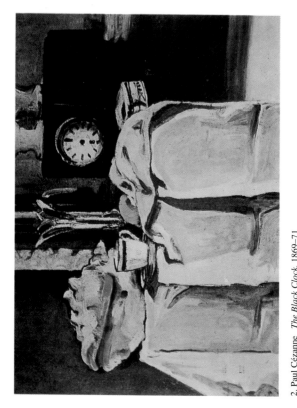

2. Paul Cézanne *The Black Clock*, 1869–71
Stavros S. Niarchos Collection, London

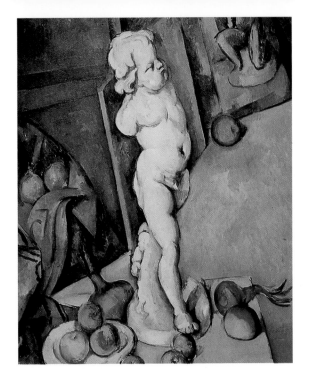

3. Paul Cézanne *Still Life with Plaster Cupid,* c. 1892
Courtauld Institute Galleries, London

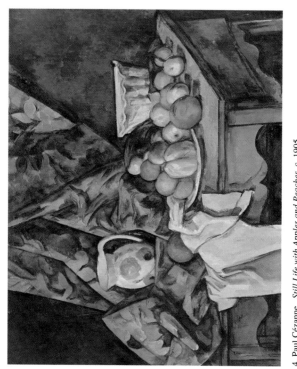

4. Paul Cézanne *Still Life with Apples and Peaches*, c. 1905
National Gallery of Art, Washington, D.C.; Gift of Eugene and Agnes Meyer

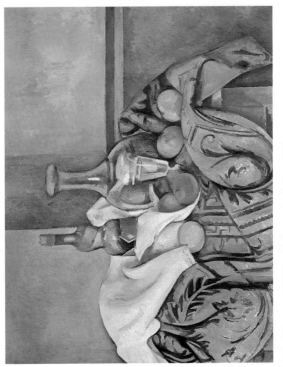

5. Paul Cézanne *Still Life with Peppermint Bottle*, c. 1894
National Gallery of Art, Washington, D.C.; Chester Dale Collection

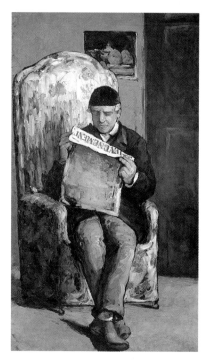

6. Paul Cézanne *Portrait of the Artist's Father,*
1866. National Gallery of Art, Washington, D.C.;
Collection of Mr. and Mrs. Paul Mellon

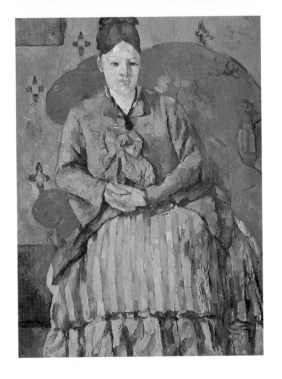

7. Paul Cézanne *Madame Cézanne in a Red Armchair*, c. 1877
Museum of Fine Arts, Boston; Bequest of Robert Treat Paine

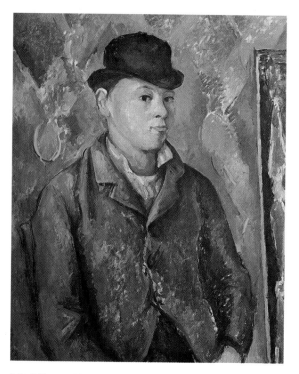

8. Paul Cézanne *The Artist's Son, Paul,* 1885–90
National Gallery of Art, Washington, D.C.; Chester Dale Collection

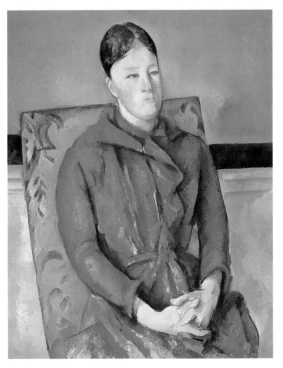

9. Paul Cézanne *Madame Cézanne in a Yellow Armchair,* 1893–95
Art Institute of Chicago; Wilson L. Mead Fund

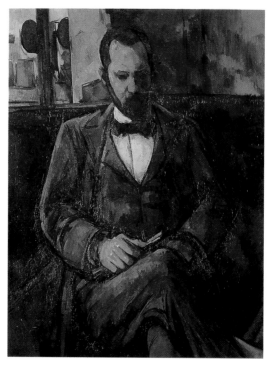

10. Paul Cézanne *Portrait d'Ambroise Vollard*, 1899
Musée du Petit Palais, Geneva

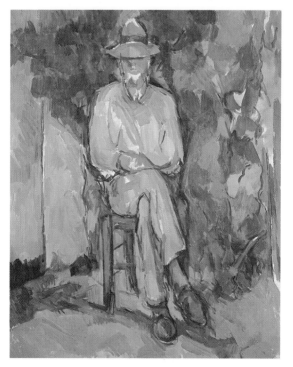

11. Paul Cézanne *The Gardener (Vallier Seated)*, 1905–6
The Tate Gallery, London

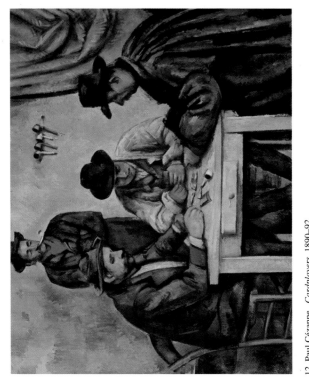

12. Paul Cézanne *Cardplayers*, 1890–92
The Metropolitan Museum of Art, New York; Bequest of Stephen C. Clark

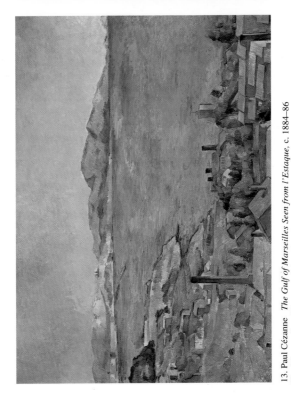

13. Paul Cézanne *The Gulf of Marseilles Seen from l'Estaque*, c. 1884–86
The Metropolitan Museum of Art, New York; The H. O. Havemeyer Collection

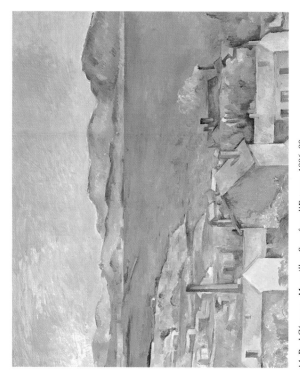

14. Paul Cézanne *Marseilles, Seen from l'Estaque*, 1886–90
Art Institute of Chicago; Mr. and Mrs. Martin A. Ryerson Collection

15. Paul Cézanne *Monte Ste.-Victoire Seen from Bibémus Quarry*, c. 1898–1906
Baltimore Museum of Art; The Cone Collection,
formed by Dr. Claribel Cone and Miss Etta Cone of Baltimore

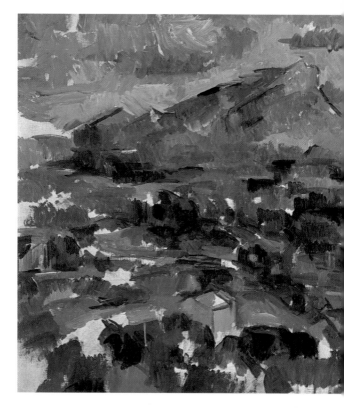

16. Paul Cézanne *Mont Ste.-Victoire
Seen from Les Lauves*, 1902–6
Kunsthaus, Zurich

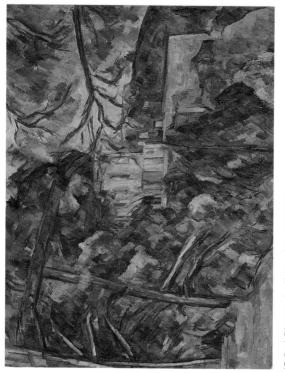

17. Paul Cézanne *Le Château Noir*, 1900/1904
National Gallery of Art, Washington, D.C.; Gift of Eugene and Agnes Meyer

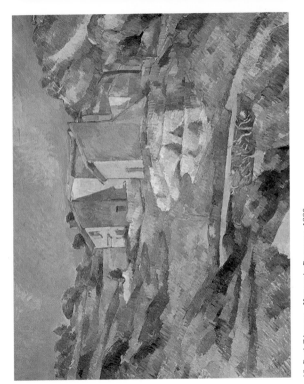

18. Paul Cézanne *Houses in Provence*, 1880
National Gallery of Art, Washington, D.C.; Collection of Mr. and Mrs. Paul Mellon

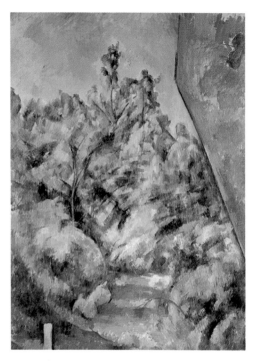

19. Paul Cézanne *Bibémus: Red Rock,* 1897
Musée D'Orsay, Paris

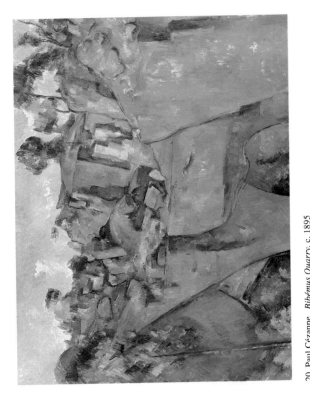

20. Paul Cézanne *Bibémus Quarry*, c. 1895
Folkwang Museum, Essen

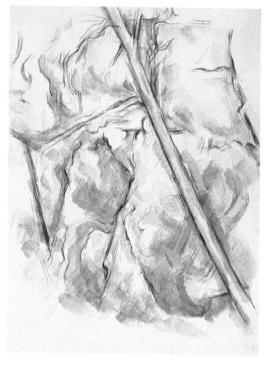

21. Paul Cézanne *Pin et rochers au château noir,* c. 1910
The Art Museum, Princeton University

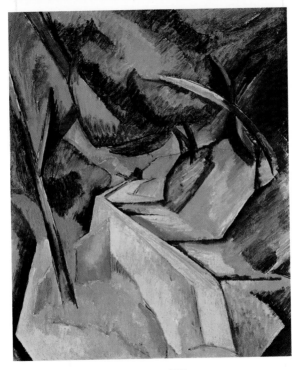

22. Georges Braque *Road near l'Estaque,* 1908
Museum of Modern Art, New York; Given anonymously

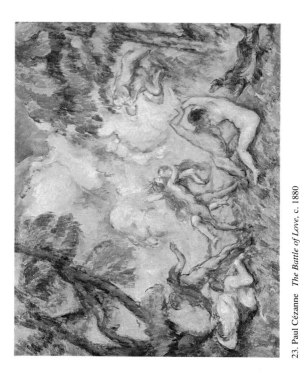

23. Paul Cézanne *The Battle of Love,* c. 1880
National Gallery of Art, Washington, D.C.; Gift of the W. Averell Harriman Foundation
in memory of Marie N. Harriman

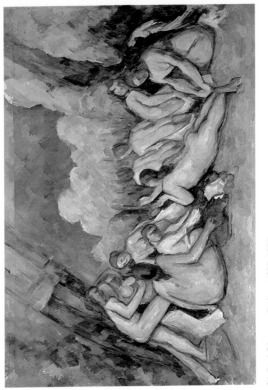

24. Paul Cézanne *Bathers*, 1900–1906
National Gallery, London

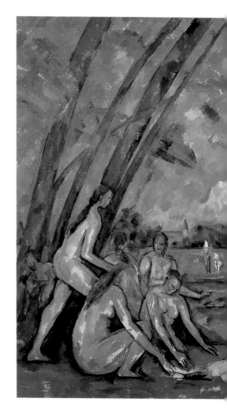

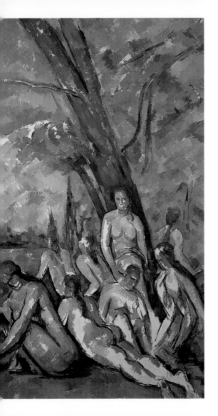

25. Paul Cézanne
Large Bathers, 1899–1905
Philadelphia Museum of Art;
W. P. Wilstach Collection

26. Paul Cézanne *Bathers*, 1899–1904
Art Institute of Chicago; Amy McCormick Memorial Collection

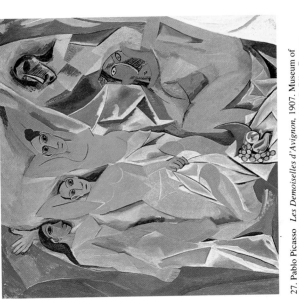

27. Pablo Picasso *Les Demoiselles d'Avignon*, 1907. Museum of Modern Art, New York; Acquired through the Lillie P. Bliss Bequest

LIST OF PLATES

(Please note: Numbers that appear in parentheses refer to plate numbers within each chapter.)

Introduction

Delacroix, Eugène *Death of Sardanapalus*, 1827–28 (1)
Denis, Maurice *April*, 1892 (3)
Gauguin, Paul *The Day of the God (Mahana No Atua)*, 1894 (4)
Whistler, James McNeill *Caprice in Purple and Gold No. 2: The Golden Screen*, 1864 (2)

Chapter 1

Boudin, Eugène *Approaching Storm*, 1864 (10)
Caillebotte, Gustave *Le Pont de l'Europe*, 1876 (18)
Caillebotte, Gustave *Street in Paris, a Rainy Day*, 1877 (19)
Cassatt, Mary *Woman in Black at the Opera*, 1880 (23)
Corot, Camille *Boatman of Mortefontaine*, 1865–70 (4)
Courbet, Gustave *The Painter's Studio*, 1855 (8)
Courbet, Gustave *Woman with a Parrot*, 1866 (9)
Daubigny, Charles-François *Soleil couchant*, 1865 (5)
Daumier, Honoré *The Laundress*, c. 1861–63 (7)
Degas, Edgar *Au théâtre*, 1880 (27)
Degas, Edgar *The Millinery Shop*, c. 1882 (25)
Degas, Edgar *Portraits in an Office: The Cotton Exchange, New Orleans*, 1873 (22)
Degas, Edgar *Woman Ironing*, 1882 (24)
Delacroix, Eugène *Liberty Leading the People*, 1830 (2)
Gogh, Vincent van *Restaurant Interior*, 1887 (29)
Gogh, Vincent van *Sidewalk Café at Night*, 1888 (30)
Ingres, Jean-Auguste-Dominique *Odalisque and Slave*, 1842 (1)
Manet, Edouard *Battle of the* Kearsage *and the* Alabama, 1864 (14)
Manet, Edouard *The Dead Toreador*, 1864 (12)
Manet, Edouard *Execution of the Emperor Maximilian*, 1867 (13)
Manet, Edouard *The Old Musician*, 1862 (11)

Manet, Edouard *The Races at Longchamps*, 1872 (15)

Millet, Jean-François *The Angelus*, 1867 (6)

Monet, Claude *Le Pont de l'Europe*, 1877 (17)

Monet, Claude *Quai du Louvre*, 1867 (16)

Pissarro, Camille *Jallais Hill, Pontoise*, 1867 (21)

Renoir, Pierre-Auguste *Pont Neuf, Paris*, 1872 (20)

Toulouse-Lautrec, Henri de *At the Moulin Rouge*, 1892 (26)

Toulouse-Lautrec, Henri de *A Corner of the Moulin de la Gallette*, 1892 (28)

Turner, J.M.W. *Houses of Parliament on Fire*, 1834 (3)

Chapter 2

Manet, Edouard *Argenteuil*, 1874 (13)

Manet, Edouard *At the Café*, 1878 (15)

Manet, Edouard *At Père Lathuille's*, 1879 (18)

Manet, Edouard *The Balcony*, 1868–69 (8)

Manet, Edouard *A Bar at the Folies Bergère*, 1882 (23)

Manet, Edouard *Boating*, c. 1874 (12)

Manet, Edouard *Déjeuner sur l'herbe (Luncheon on the Grass)*, 1863 (9)

Manet, Edouard *Departure of the Folkestone Boat*, 1869 (10)

Manet, Edouard *Flowers in a Crystal Vase*, c. 1882 (22)

Manet, Edouard *Gare St.-Lazare (Le Chemin de fer)*, 1873 (17)

Manet, Edouard *In the Conservatory*, 1879 (16)

Manet, Edouard *Le Bal de l'opéra*, 1873 (24)

Manet, Edouard *Le Journal Illustré*, c. 1878–79 (20)

Manet, Edouard *Lola de Valence*, 1862 (2)

Manet, Edouard *Mademoiselle Victorine in the Costume of an Espada*, 1862 (3)

Manet, Edouard *Monet in His Studio Boat*, 1874 (11)

Manet, Edouard *Music in the Tuileries*, 1862 (6)

Manet, Edouard *Nana*, 1877 (5)

Manet, Edouard *Olympia*, 1863 (1)

Manet, Edouard *The Plum*, c. 1877 (14)

Manet, Edouard *Portrait of Alphonse Maureau*, c. 1880 (19)

Manet, Edouard *Portrait of Emile Zola*, 1868 (4)
Manet, Edouard *Still Life with Melon and Peaches*, 1866 (21)
Manet, Edouard *The Street Singer*, 1862 (7)

Chapter 3
Bazille, Frédéric *The Artists's Studio*, 1870 (12)
Bazille, Frédéric *Bathers (Scene d'eté)*, 1869 (2)
Cassatt, Mary *The Boating Party*, 1893–94 (21)
Cassatt, Mary *Lady at the Tea Table*, 1885 (27)
Cassatt, Mary *The Loge*, 1882 (26)
Cézanne, Paul *House of Père Lacroix*, 1873 (10)
Degas, Edgar *Carriage at the Races*, 1871–72 (9)
Degas, Edgar *Foyer de la danse (The Dancing Class)*, 1871 (13)
Degas, Edgar *L'Absinthe*, 1876 (23)
Degas, Edgar *Portrait of Duranty*, 1879 (25)
Monet, Claude *Boulevard des Capucines*, 1873 (11)
Monet, Claude *The Bridge at Argenteuil*, 1874 (16)
Monet, Claude *Impression, Sunrise*, c. 1872 (1)
Monet, Claude *La Grenouillère*, c. 1869 (3)
Monet, Claude *Regatta at Argenteuil*, 1872 (7)
Morisot, Berthe *The Artist's Sister, Madame Pontillon, Seated on Grass*, 1873 (14)
Morisot, Berthe *Eté*, c. 1879 (24)
Morisot, Berthe *The Harbor at Lorient*, 1869 (5)
Pissarro, Camille *Orchard in Bloom, Louveciennes*, 1872 (15)
Renoir, Pierre-Auguste *Dancing at the Moulin de la Galette*, 1876 (20)
Renoir, Pierre-Auguste *La Balançoire*, 1876 (22)
Renoir, Pierre-Auguste *La Grenouillère*, c. 1869 (4)
Renoir, Pierre-Auguste *Regatta at Argenteuil*, c. 1874 (17)
Sisley, Alfred *The Bridge at Villeneuve-la-Garenne*, 1872 (6)
Sisley, Alfred *Early Snow at Louveciennes*, 1874 (18)
Sisley, Alfred *The Flood at Port Marly*, 1876 (19)
Sisley, Alfred *Village Street in Marlotte*, 1866 (8)

Chapter 4

Monet, Claude *The Artists's Garden at Vétheuil*, 1880 (16)

Monet, Claude *Bazille and Camille*, 1865 (1)

Monet, Claude *The Beach at Trouville*, 1870 (7)

Monet, Claude *Bordighera*, 1884 (17)

Monet, Claude *Bordighera*, 1884 (18)

Monet, Claude *Field of Poppies*, 1873 (4)

Monet, Claude *Gare St.-Lazare*, 1877 (14)

Monet, Claude *Haystack in Winter*, 1891 (19)

Monet, Claude *The Japanese Footbridge and the Water Lily Pond, Giverny*, 1899 (25)

Monet, Claude *Jean Monet on His Wooden Horse*, 1872 (8)

Monet, Claude *La Japonaise*, 1876 (29)

Monet, Claude *The Luncheon*, 1868 (12)

Monet, Claude *Palazzo da Mula*, 1908 (28)

Monet, Claude *Parisians Enjoying the Parc Monceau*, 1878 (11)

Monet, Claude *The Picnic*, 1866 (3)

Monet, Claude *The Poplars*, 1891 (22)

Monet, Claude *Poplars on the Bank of the Epte River*, 1891 (21)

Monet, Claude *Red Boats at Argenteuil*, 1875 (10)

Monet, Claude *The River*, 1868 (6)

Monet, Claude *Rouen Cathedral, Portal and Albane Tower*, 1894 (23)

Monet, Claude *Rouen Cathedral, Sunset*, 1894 (24)

Monet, Claude *Rue Saint-Denis*, 1878 (15)

Monet, Claude *St.-Lazare Station: The Arrival of the Train from Normandy*, 1877 (13)

Monet, Claude *Terrace at Ste.-Adresse*, 1866–67 (5)

Monet, Claude *Two Haystacks*, 1891 (20)

Monet, Claude *Water Garden and Japanese Footbridge*, 1900 (26)

Monet, Claude *Water Lilies I*, 1905 (27)

Monet, Claude *Woman with a Parasol: Madame Monet and Her Son*, 1875 (9)

Monet, Claude *Women in the Garden*, 1866–67 (2)

Chapter 5

Renoir, Pierre-Auguste *Bather Arranging Her Hair*, 1893 (26)

Renoir, Pierre-Auguste *Bathers*, 1887 (27)

Renoir, Pierre-Auguste *Dance in the Country*, 1883 (6)

Renoir, Pierre-Auguste *The Dancer*, 1874 (13)

Renoir, Pierre-Auguste *Diana*, 1867 (25)

Renoir, Pierre-Auguste *Girl with a Hoop*, 1885 (21)

Renoir, Pierre-Auguste *A Girl with a Watering Can*, 1876 (4)

Renoir, Pierre-Auguste *In the Meadow*, c. 1890 (23)

Renoir, Pierre-Auguste *Lady at the Piano*, c. 1875–76 (16)

Renoir, Pierre-Auguste *La Loge*, 1874 (11)

Renoir, Pierre-Auguste *Le Déjeuner*, 1879 (17)

Renoir, Pierre-Auguste *Lise with a Parasol*, 1867 (10)

Renoir, Pierre-Auguste *The Luncheon of the Boating Party*, 1881 (1)

Renoir, Pierre-Auguste *Madame Charpentier with Her Children, Georgette and Paul*, 1878 (19)

Renoir, Pierre-Auguste *Madame Clapisson (Lady with a Fan)*, 1883 (22)

Renoir, Pierre-Auguste *Madame Monet and Her Son in Their Garden*, 1874 (14)

Renoir, Pierre-Auguste *Mademoiselle Sicot*, 1865 (9)

Renoir, Pierre-Auguste *Mother and Children*, c. 1874–76 (5)

Renoir, Pierre-Auguste *Odalisque*, 1870 (24)

Renoir, Pierre-Auguste *Oarsmen at Chatou*, 1879 (2)

Renoir, Pierre-Auguste *On the Terrace*, 1881 (20)

Renoir, Pierre-Auguste *Portrait of Alfred Sisley*, 1874 (12)

Renoir, Pierre-Auguste *Sailboats at Argenteuil*, 1873–74 (3)

Renoir, Pierre-Auguste *Spring Bouquet*, 1866 (7)

Renoir, Pierre-Auguste *Two Little Circus Girls*, 1879 (18)

Renoir, Pierre-Auguste *Woman with a Cat*, c. 1875 (15)

Renoir, Pierre-Auguste *Young Woman Sewing*, 1879 (8)

Chapter 6

Degas, Edgar *Achille de Gas in the Uniform of a Cadet*, 1856–57 (6)

Degas, Edgar *At the Milliner's*, c. 1882 (13)

Degas, Edgar *At the Milliner's*, 1882 (15)

Degas, Edgar *At the Milliner's*, 1882–85 (16)

Degas, Edgar *The Ballet Class*, c. 1880 (19)

Degas, Edgar *The Bellelli Family*, 1858–62 (3)

Degas, Edgar *Chanteuse au gant*, 1878 (12)

Degas, Edgar *Dancers at the Old Opera House*, c. 1877 (11)

Degas, Edgar *Dancers, Pink and Green*, c. 1890 (20)

Degas, Edgar *Edmondo and Thérèse Morbilli*, c. 1865 (5)

Degas, Edgar *Four Dancers*, c. 1899 (21)

Degas, Edgar *Jacques Joseph Tissot*, 1868 (7)

Degas, Edgar *Madame René de Gas*, 1872–73 (8)

Degas, Edgar *Madame Camus*, 1869–70 (9)

Degas, Edgar *Miss Lala at the Circus Fernando*, 1879 (17)

Degas, Edgar *The Races*, c. 1873 (1)

Degas, Edgar *The Tub*, 1886 (2)

Degas, Edgar *Uncle and Niece (Portrait of Henri and Lucy de Gas)*, c. 1876 (10)

Degas, Edgar *Woman with Chrysanthemums*, 1865 (4)

Degas, Edgar *Woman in a Rose Hat*, 1879 (14)

Toulouse-Lautrec, Henri de *A la mie*, 1891 (24)

Toulouse-Lautrec, Henri de *Alfred la Guigne*, 1894 (26)

Toulouse-Lautrec, Henri de *Au salon de la Rue des Moulins*, 1894 (23)

Toulouse-Lautrec, Henri de *The Englishman at the Moulin Rouge*, 1892 (22)

Toulouse-Lautrec, Henri de *In the Circus Fernando: The Ringmaster*, 1888 (25)

Toulouse-Lautrec, Henri de *La Toilette*, 1896 (29)

Toulouse-Lautrec, Henri de *May Milton*, 1895 (28)

Toulouse-Lautrec, Henri de *Quadrille at the Moulin Rouge*, 1892 (21)

Toulouse-Lautrec, Henri de *Yvette Guilbert Taking a Curtain Call*, 1894 (27)

Chapter 7

Angrand, Charles *Man and Woman in the Street*, 1887 (5)

Cross, Henri Edmond *The Golden Islands*, 1892 (13)

Gauguin, Paul *D'où Venons Nous . . . Que Sommes Nous . . . Où Allons Nous?*, 1897 (27)

Gauguin, Paul *Old Women of Arles*, 1888 (24)

Gauguin, Paul *Self-Portrait with Halo*, 1889 (26)

Gauguin, Paul *Vision after the Sermon: Jacob Wrestling with the Angel*, 1888 (25)

Renoir, Pierre-Auguste *Dance in the City*, 1883 (3)

Seurat, Georges *Bathers at Asnières*, 1884 (6)

Seurat, Georges *The Circus*, 1891 (11)

Seurat, Georges *Invitation to the Sideshow (La Parade)*, 1887–88 (9)

Seurat, Georges *Le Chahut*, 1889–90 (12)

Seurat, Georges *Model from the Back*, 1887 (7)

Seurat, Georges *Seascape at Port-en-Bessin, Normandy*, 1888 (10)

Seurat, Georges *A Sunday Afternoon on the Island of La Grande Jatte*, 1884–86 (1)

Seurat, Georges Study for *A Sunday Afternoon on the Island of La Grande Jatte*, 1884–86 (2)

Seurat, Georges *Woman Powdering Herself*, 1889–90 (8)

Signac, Paul *Gas Tanks at Clichy*, 1886 (4)

Gogh, Vincent van *Drawbridge near Arles*, 1888 (19)

Gogh, Vincent van *Gauguin's Armchair*, 1888 (22)

Gogh, Vincent van *Haystacks in Provence*, 1888 (20)

Gogh, Vincent van *The Night Café*, 1888 (23)

Gogh, Vincent van *Portrait of Madame Ginoux (L'Arlésienne)*, 1888 (18)

Gogh, Vincent van *The Potato Eaters*, 1885 (15)

Gogh, Vincent van *Still Life with the Bible*, 1885 (16)

Gogh, Vincent van *Sunflowers*, 1888 (17)

Gogh, Vincent van *Three Pairs of Shoes*, 1887 (14)

Gogh, Vincent van *Van Gogh's Chair and Pipe*, 1888–89 (21)

Chapter 8

Braque, Georges *Road near l'Estaque*, 1908 (22)

Cézanne, Paul *The Artist's Son, Paul*, 1885–90 (8)

Cézanne, Paul *The Basket of Apples*, c. 1985 (1)

Cézanne, Paul *Bathers*, 1899–1904 (26)

Cézanne, Paul *Bathers*, 1900–1906 (24)

Cézanne, Paul *The Battle of Love*, c. 1880 (23)

Cézanne, Paul *Bibémus Quarry*, c. 1895 (20)

Cézanne, Paul *Bibémus: Red Rock*, 1897 (19)

Cézanne, Paul *The Black Clock*, 1869–71 (2)

Cézanne, Paul *Cardplayers*, 1890–92 (12)

Cézanne, Paul *The Gardener (Vallier Seated)*, 1905–6 (11)

Cézanne, Paul *The Gulf of Marseilles Seen from l'Estaque*, c. 1884–86 (13)

Cézanne, Paul *Houses in Provence*, 1880 (18)

Cézanne, Paul *Large Bathers*, 1899–1905 (25)

Cézanne, Paul *Le Château Noir*, 1900/1904 (17)

Cézanne, Paul *Madame Cézanne in a Red Armchair*, c. 1877 (7)

Cézanne, Paul *Madame Cézanne in a Yellow Armchair*, 1893–95 (9)

Cézanne, Paul *Marseilles, Seen from l'Estaque*, 1886–90 (14)

Cézanne, Paul *Monte Ste.-Victoire Seen from Bibémus Quarry*, c. 1898–1906 (15)

Cézanne, Paul *Mont Ste.-Victoire Seen from Les Lauves*, 1902–6 (16)

Cézanne, Paul *Pin et rochers au château noir*, c. 1910 (21)

Cézanne, Paul *Portrait d'Ambroise Vollard*, 1899 (10)

Cézanne, Paul *Portrait of the Artist's Father*, 1866 (6)

Cézanne, Paul *Still Life with Apples and Peaches*, c. 1905 (4)

Cézanne, Paul *Still Life with Peppermint Bottle*, c. 1894 (5)

Cézanne, Paul *Still Life with Plaster Cupid*, c. 1892 (3)

Picasso, Pablo *Les Demoiselles d'Avignon*, 1907 (27)

SELECTED **TINY FOLIOS**™ FROM ABBEVILLE PRESS

- American Impressionism 978-0-7892-0612-1
- Antonio Gaudí: Master Architect 978-0-7892-0690-9
- Audubon's Birds of America 978-0-7892-0814-9
- Botanica Magnifica: Portraits of the World's Most Extraordinary Flowers and Plants 978-0-7892-1137-8
- Frank Lloyd Wright: America's Master Architect 978-0-7892-0227-7
- Illuminated Manuscripts: Treasures of the Pierpont Morgan Library 978-0-7892-0216-1
- Japanese Prints: The Art Institute of Chicago 978-0-7892-0613-8
- Norman Rockwell: 332 Magazine Covers 978-0-7892-0409-7
- Treasures of British Art: Tate Gallery 978-0-7892-0541-4
- Treasures of Impressionism and Post-Impressionism: National Gallery of Art 978-0-7892-0491-2
- Treasures of the Addison Gallery of American Art 978-0-7892-0758-6
- Treasures of the Art Institute of Chicago: Paintings from the 19th Century to the Present 978-0-7892-1288-7
- Treasures of the Louvre 978-0-7892-0406-6
- Treasures of the Museum of Fine Arts, Boston 978-0-7892-1233-7
- Treasures of the National Gallery, London 978-0-7892-0482-0
- Treasures of the Prado 978-0-7892-0490-5
- Treasures of the Uffizi 978-0-7892-0575-9
- Women Artists: National Museum of Women in the Arts 978-0-7892-1053-1